Richard Box

Drawing
for the
terrified!

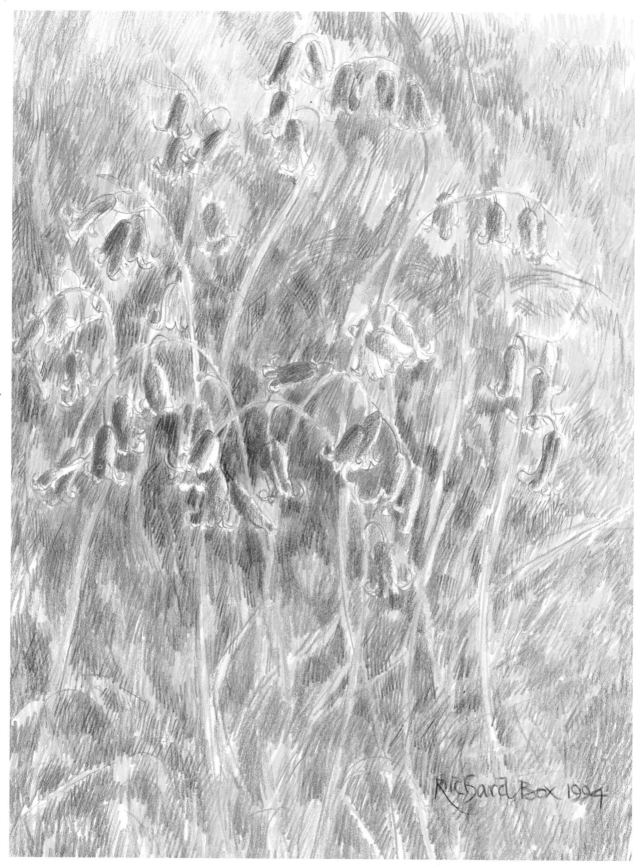

BLUEBELLS

Richard Box

Drawing
for the
terrified!

A complete course for beginners

David & Charles

DEDICATION

I am grateful for all the past, present and future *Drawing for the Terrified*
students without whom this book would not be possible.
I dedicate this book to you all.

Unless otherwise stated, all photographs and illustrations
are by the author

A DAVID & CHARLES BOOK

First published in the UK in 1997
Reprinted 1999
First published in paperback 1999

Copyright © Richard Box 1997

Richard Box has asserted his right to be identified as author of
this work in accordance with the Copyright, Designs and Patents Act, 1988.

A catalogue record for this book is available from the British Library.

ISBN 0 7153 0351 1 (h/b)
ISBN 0 7153 0860 2 (p/b)

Book design by Les Dominey Design Company, Exeter
and printed in Italy
by LEGO SpA, Vincenza
for David & Charles
Brunel House Newton Abbot Devon

Contents

INTRODUCTION

Addressing and allaying terrors

Dear Reader

Why are so many of us terrified of drawing? To find out, we first need to examine the nature of terror. This story, 'The Giant', may help. Are you sitting comfortably?

THE GIANT

Once upon a time there stood a poverty-stricken village at the foot of a mountain. On top of the mountain was some hidden treasure, which would solve all the villagers' problems, but the treasure was guarded by an enormous giant, who bellowed so ferociously at anyone who climbed the mountain that no villager dared to do so. The villagers remained poor, existing on what little they could grow in the mountain's shadow.

Then one year, disaster struck – the harvest failed. The villagers turned to their king for help. Unless the king could bring back the treasure they would all starve to death. With trepidation in his heart and the last loaf of bread in his knapsack, the king set off up the mountain. As he climbed, the giant suddenly pounced from behind a huge boulder. Sure enough he was enormous, he roared horribly and tried to terrify the king out of his wits. He nearly succeeded, but instead of running away, the king braced himself and took one tiny step towards the giant. Was it his imagination, or had the giant shrunk an inch? He took another step forward and the giant seemed to shrink a little more. This diminution continued until the king, upon reaching the giant, was able to hold him in the palm of his hand. 'You don't look much like a giant now,' said the king. 'We'll have to call you something else. What is your name anyway?' In a weak and feeble voice the giant replied, 'My name is Terror!'

The point of this story is to tell us that terror is all in the mind. Facing our fears is the first step we can make towards conquering them, and is also the way to discover real treasure which is not really hidden.

For all things are less dreadful than they seem.

WILLIAM WORDSWORTH

Let us take another step together and remember how we were all once able to draw. Furthermore, we were all able to do so before we were taught to read, write or do arithmetic.

As it is now generally accepted that the potential for literacy and numeracy is innate in us all, so the ability to draw is also innate. Everyone is capable of drawing.

Look at the drawings on pages 7–8 which show the progression of children's drawings and paintings from about four to eleven years old. All children begin scribbling, then very soon begin to form what are known as 'schemata', which are a series of marks starting as fairly rudimentary and later developing into quite an elaborate system, all representing their responses to the world around them. Some of the drawings shown are by my nieces, some are by the children of friends, others, alas are anonymous. The child was nearly four years old when she painted the picture *Wonder* on the opposite page and having a wonderful time with paint. She was probably working at an easel, and the paint pots of bright colours were arranged in order and in each one there was a lovely big brush. What fun she had making that picture!

There are two extremely important points

WONDER

at nearly four years old

about the making of this picture, indeed, about the making of any picture. Firstly, the child was completely absorbed in what she was doing, in the discovery of the paint's substance, its colours and textures, and in how she could control the paint with the brushes but also how the paint and brushes seemed to control her as well, and this made the whole process of creation a pleasure. Secondly, she did not tear up her picture in a temper and put it in the wastepaper basket!

Proper attention to the finishing, strengthening, of the means, is what we need. With the means all right, the end must come.

SWAMI VIVEKANANDA

You have probably already realised that these two points are concerned with the relationship between the process and the result (or as Swami Vivekananda would say, 'the means' and 'the end'). Young children can become so absorbed in an activity that it seems as if they are entranced; it seems that as adults we become too 'grown up' for such childlike wonder. With maturity comes necessary self-criticism. However, we must beware that it should be positive and not what might be described as 'the adult disease of doubt', otherwise we might focus on what we judge 'wrong'

and, in doing so, fail to notice other qualities which are 'right' – enter the wastepaper basket! In its advanced stages, sufferers become so dubious of their ability to succeed that they develop a terror not only of failure ('the end'), but also of the learning process ('the means') by which that end can be achieved. (Now read the story of 'The Giant' again!)

There is a third point which needs to be made now, and this concerns the nature of knowledge and understanding.

Look at the drawing at left again and you will see that as well as red, yellow and blue, there are green, orange and purple colours in the picture. These last three colours, known as secondary colours, have been made by mixing pairs of the first three colours, which are known as primary colours. Look again at the picture and you will see some areas, slightly below and left of centre, which appear greyish-brown. Grey and brown can be made by mixing together the three primary colours in varying proportions. (We shall learn how to do all this later on.) Remember, this child was only four years old. She was no doubt aware that something was happening, otherwise her attention would not have been so absorbed, but at that age she could not have been fully aware of what exactly it was, or how. The knowledge was latent. We need to remember this, particularly when we feel like destroying something we have made because we may be throwing away knowledge we have not yet recognised.

The thing that hath been, it is that which shall be; and that which is done is that which shall be done: and there is no new thing under the sun.

ECCLESIASTES 1:8

It is true that there is nothing new under the sun, and this book contains many well-known facts and well tried procedures and methods. However, your *understanding* of these facts and how you put them into practice will be different from anyone else's, and in this sense your drawings will be unique.

Indeed your drawings and all the children's drawings in this sense, are already unique. Although the examples shown are typical, they

THE DEATH OF EURYDICE
at about seven years old

THE TEAPARTY
at about eight years old

A STILL-LIFE GROUP
at ten or eleven years old

also all have a particular character. No one has ever painted or drawn them exactly like this before or since. They are each unique.

All our knowledge has its origins in our perceptions.

LEONARDO DA VINCI

When we are about five years old we conceive the sky as being 'up there'. By about seven years old we perceive that it appears to 'come down' to the ground. *The Death of Eurydice* (see left) represents the story of Orpheus and Eurydice when Eurydice is bitten by a snake and dies. The child certainly had a rich array of coloured crayons! Look at the variety of greens in the grass and all those blues in the sky, which has been represented as visually perceived. It is brought down to meet the grass and represented as behind the characters in the drama. It is even behind the 'bubble' emerging from the mouth of Eurydice's best friend as she cries out 'Oh dear!' in her grief. Nevertheless, the child's spatial orientation was not completely consistent. Notice the two figures high up in the picture. Concerned that they looked as if they are floating or even flying, and knowing that there were no fairies or angels in this particular story, the child found her own way of placing them on the ground by putting some green grass under and around their feet. Thus, in her own unique way, she solved this rather major problem, instead of getting into a furious temper, judging the picture 'wrong' and tearing it up into small pieces.

The next picture I have chosen from my collection, *The Teaparty* (see left), illustrates a tea party where lots of different creatures are arranged around a table. Two points about this drawing merit our attention. First, the picture is not finished, but we can easily imagine from the information provided how it will look on completion. Whereas young children tend to allow their pictures to evolve as they draw or paint them, this eight-year-old girl exhibits a degree of forward planning. Second, a 'multiple viewpoint' has been used. We see the plates of cakes from a bird's-eye viewpoint (known as 'plan'), but the legs of the table and the mugs are seen as if we are standing on the ground. (This viewpoint is known as 'elevation'.) The creatures to the right are pointing

upward and those on the left are pointing downward. Such multiple viewpoints are devices to portray what is understood in conceptual terms and are typical not only in children's art all over the world, but in many societies from ancient times to the present day. Alas, it is usually at about this age that many of us stop drawing.

WHY DO SO MANY OF US STOP DRAWING?

The answer is sadly simple. We do not recognise the value of our conceptual drawings, nor do we take the necessary steps to learn to draw perceptually. As we grow, our critical faculties develop, which can be as negative as they are constructive, and we soon learn to judge our attempts as inadequate. Insensitive remarks from adults such as 'What's that supposed to be?' are hardly helpful. Alongside this we are taught that writing and arithmetic are more, rather than *equally*, important. Consequently, many of us neglect to continue to practise any of our drawing skills. Many years later, when we attempt to draw again, we are appalled at the results. Once more we are focusing on a negative view of the 'end' rather than on what might be an enjoyable process of exploring the 'means', irrespective of the result. Perhaps we should ask another question:

WHAT IS DRAWING?

Drawing has meant many things at different times and in different places. However, for the duration of this book we shall be investigating the meaning of perceptual drawing.

Drawing is a means of finding your way about things and a way of experiencing more quickly several tryouts and attempts.

HENRY MOORE

This statement emphasises that drawing is a continuous process of discovery. If we know that we can pursue several 'tryouts and attempts' our fear of making mistakes is instantly alleviated because of the safety in numbers. Now we can allow ourselves to experiment more easily and quickly. No longer do we need to give up because our earlier fear of failure now takes the form of exploration and discovery.

Later in the book I shall suggest that you try several 'tryouts and attempts' concurrently. By doing so, you will be able to transfer each new discovery from one drawing to another, whether this is something that has been discovered about the nature of the subject, the nature of the materials and tools, or, indeed, the nature of the process of drawing itself.

Can drawing be taught, and can it be learned? The answer to both these questions is emphatically, 'yes'. Your innate potential to draw might have been impeded, but it is certainly still present. You have known how to draw conceptually; now you are ready to learn to draw perceptually. If you are willing to learn, to follow some guidelines and to be disciplined in your practice, there is no reason why you should not become really quite skilled at drawing what you see. The still life (on page 8, bottom), was drawn by a child of ten who was taught to draw perceptually. He followed the same guidelines that you are about to be presented with in this book. The ensuing chapters will teach you to use your perceptual powers and will show you how to reproduce what you see.

The advice given will help you to nurture your developing skills and abilities. Each chapter leads on from the last, so they should be read in sequence. Further, not only is the book a progressive course, it is also a practical 'voyage of discovery' containing pages of adventure gradually revealing new possibilities for you to explore. Avoid succumbing to the terror of the learning experience. Nurture yourself carefully and enjoy doing the exercises for their own sake – avoid threatening yourself with high expectations. If you proceed in this way, you will suddenly realise that you can draw! This rewarding consequence will result from your allowing your learning experience to be full of childlike joy and wonder, rather than the terror wrought by the 'adult disease of doubt'.

Children think not of what is past, nor what is to come, but enjoy the present time, which few of us do.

JEAN DE LA BRUYERE

CHAPTER ONE

Preparation

MATERIALS AND EQUIPMENT

The following list contains the minimum you will need to proceed with all of the main exercises in this book. You can, of course, add more items to it as you progress.

You will need
A drawing board
At least four drawing-board clips
Lead pencils
A pencil sharpener or craft knife
White drawing paper
An eraser
Coloured pencils
A viewfinder

Let us examine these items in detail.

Drawing board You could either buy one ready-made or you could make your own from an offcut of plywood or blockboard about 58cm (23in) by 40cm (16in), the edges of which should be sanded smooth.

Drawing-board clips These are obtainable from art shops, or use large bulldog clips instead.

Lead pencils You will need only a few to begin with. Good quality pencils can be purchased at most stationery shops and all art suppliers.

Pencil sharpener Any sharpener will do, although many artists prefer to use a light-handled craft knife (if the knife is too heavy it may chop the pencil in half!).

Craft knife Sharpening with a blade gives a much longer lead with which to draw. The fine point at the tip will be the same by either method of sharpening, but the longer lead, when used on the side, will produce longer, and thus larger, marks.

White drawing paper Cartridge paper is available at most art shops. Its texture is slightly rough, which many artists prefer because of the 'conversation' that occurs between its surface and the pencil. I like to draw on watercolour paper which is even rougher because of its many tiny humps and hollows.

Eraser This needs to be soft and pliable. Many art suppliers stock 'putty rubbers' which erase efficiently without smudging or scuffing the paper.

Coloured pencils Buy pencils of good quality – the best you can afford (my preference is for those made by Caran d'Ache). For our purposes, avoid wax crayons or pastels which sometimes come in pencil form. Pencils can be either water resistant or water soluble; I prefer the water-soluble variety, which, although I rarely use them with water, I find have superior mark-making qualities.

To pursue all the exercises in colour in this book you will need only six colours: two blues, two reds and two yellows. One blue should be biased towards purple such as royal blue or ultramarine, and the other towards green such as cerulean or even turquoise. You will need a red biased towards purple such as crimson, and another towards orange such as scarlet. Finally, you need a yellow biased towards green such as lemon yellow, and a yellow which is biased towards orange such as cadmium yellow or even gamboge. You will discover that from these hues of the three primary colours you will be able to make many hues of the secondary colours and also various greys, browns and the appearance of black.

You may add to this list if you wish, but you should always include the six colours which are listed above.

Viewfinder As its name implies, this is a device which helps you to find the actual 'view' from the entire scene or subject you have chosen to draw (see page 38 for an example of its use).

To make one simply take two firm pieces of

card about 200mm (8in) square from which you cut two 25mm (1in) wide L-shapes. Clip these together with bulldog clips to form a rectangle. The clips also create 'legs' for the viewfinder to stand on. You can alter the size and proportions of the viewfinder to suit your subject.

SELF-PREPARATION

The most important piece of equipment that needs preparing is ourselves! As with any activity, we need to be in 'the right frame of mind'. At the start of all my *Drawing for the Terrified* classes I encourage students to join me in an exercise which combines both relaxation and concentration which I call the Golden Cord. This is your first activity.

THE GOLDEN CORD

The exercise should be performed sitting in an upright chair. Shift your bottom well to the back of the chair, keeping both your feet gently but firmly on the ground. Allow your spine to rest against the back of the chair. This posture is important, so choose a chair that allows you to adopt the position without discomfort. Once you are comfortably seated, allow yourself to 'sink' into the chair. Close your eyes, let your head droop and allow your arms to dangle down by your sides like soggy spaghetti. Allow your breathing rate to slow down just a little. Now 'speak' to all parts of your body (your feet, your legs, your arms, your shoulders, your neck and your head) and say to them each in turn, 'Everything is all right... there is nothing to worry about... everything is all right.'

The mind is always active, even in sleep it creates dreams, so in order for it to become peaceful we need to encourage it away from troublesome thoughts and help it towards thoughts that are calm, serene and pleasant.

The way I do this, and which you can do too, is by imagining a glittering golden cord. One end of this cord is attached to the top of your head and the other is suspended from heaven. (The piano teacher who taught me this analogy invites all her students to think of this cord because it immediately enables them to sit in the appropriate position for playing the piano, which is equally appropriate for drawing *and* for this relaxed but attentive exercise.) Your spine is now erect. However, it is not rigid or tense but upright in a relaxed fashion. Because of this position, the spine need not now rest against the back of the chair; it can be self-supporting. Remember that the spine extends to the back of the neck, so your head should be in alignment with your body as if you were looking straight ahead. However, for the time being keep your eyes gently closed.

Allow your arms to come up and let your hands rest in your lap or if you prefer on your thighs. Your palms can face either upwards or downwards, it really does not matter – though I must tell you one of my students decided always to position her hands with the palms facing upwards because she had ten more golden cords 'inspiring her fingers and thumbs'! You are now in the appropriate position to begin the exercise.

Everything that comes to the mind comes through the gate of sense.

JEAN-JACQUES ROUSSEAU

The senses of sight, hearing, touch, taste and smell operate for most of us very well. Unless one or more of our senses are impaired, most of us tend to take them very much for granted; so let us now focus on three of our senses and try to be very much aware of what we notice, and how much there is to notice.

Attend first to your sense of touch. Notice the gentle pressure of your bottom on the seat of the chair. Try to be specific. Notice the touch of the left buttock and now the right buttock. Now notice your feet on the ground. Once more, be specific and avoid general impressions. Notice the touch of whatever you have on your feet. Notice the sole of your right foot and now the heel of your left foot. Notice the instep of your right foot and the toes of your left foot. Become aware of the differences between how these parts of your feet are being touched by your socks or stockings and shoes. Now notice how the other parts of your clothing touch the other parts of your body. Notice the calves, the knees and the thighs, notice the trunk of your body, the base of your spine and around your pectoral regions, and then notice the

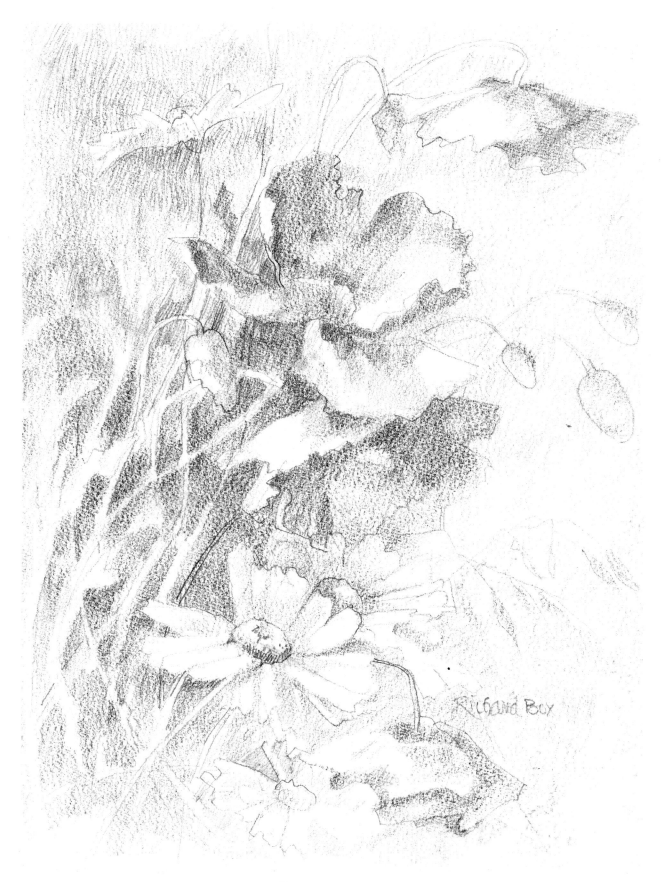

POPPIES AND DAISIES

sleeves on your arms, the cuffs on your wrists and the collar around your neck.

Feel the temperature of the air on the bare parts of your skin. Once again be specific and avoid generalisation. Notice the palm of your left hand and your right thumb tip. Notice your left ear lobe and your right cheek, your brow and your chin. If you allow your jaw to lower itself as it relaxes and if you breathe in through your mouth, you will notice the temperature of the air on your upper lip, your lower lip, your tongue, your palate and the back of your throat.

Now shift your attention from being aware of your sense of touch to your sense of hearing. Keeping your eyes closed, listen to your breathing either in through the nose and out through the mouth or vice versa. Try both ways and become aware of any change of sound. Allow your breathing to be easy. Avoid forced breathing movements. Let your lungs operate normally. Now listen to other sounds in the room, which may be the ticking of a clock or the occasional squeak of your chair. Then allow yourself to listen to sounds beyond the room, to the other parts of the building and even outside. Is there birdsong? Distant traffic? Allow whatever sounds occur to register in an objective, even dispassionate manner. If you become involved with any of the sounds, such as expressing delight at one or annoyance with another, there is a danger that you might still 'hear' it in your imagination, even after it has passed, thus making you 'deaf' to sounds which are really there. You would be 'listening' to your imagination instead of being in the present, and attending to what is happening now, which is the whole purpose of this exercise.

*The understanding which we want
is an understanding of an insistent present. The only
use of a knowledge of the past is to equip us for the
present... the present contains all that there is, it is
holy ground; for it is the past and it is the future.*

A. N. WHITEHEAD

A helpful way to be more exact when practising this exercise is to avoid *interpreting* any of the sounds you hear. The mind is very quick and for much of our daily lives *needs* to make sense of

such stimuli. However, for the time being, try not to interpret or *make sense* of what you hear. Try to *accept each sound for what it is* rather than worrying about what might be causing it or what it signifies. Try these following ways: listen to each sound in terms of its volume, notice its relative quietness or loudness; listen to each sound in terms of its pitch, notice how high or low it is in the register of sound; listen to the duration of the sound, notice how long or how short a time it continues; finally, be attentive to the intervals of silence between or, rather, those containing the sounds. Indeed, *be particularly attentive to the sound of silence.*

It is significant that many have believed in the importance of silence. The 'Desiderata' begins: 'Go placidly amid the noise and haste and remember what peace there may be in silence.' Mozart, when asked what he considered to be the most important element in his music replied, 'The silence.' So now return to listening to your breathing and notice that there is a tiny space of silence between each intake and exhalation of breath. Be attentive to these spaces of silence for a little while. Now allow yourself to notice an inner silence. There is a quietness that has become part of your very being. Remember that it is possible to return to this tranquil state whenever you desire, using the very means by which you have now arrived. Also remember that we move most efficiently and confidently from a state of stillness and inner quietness.

*In quietness and in confidence
shall be your strength.*

ISAIAH 30:15

We now come to the final part of the Golden Cord which is to explore the sense of sight. Allow your eyes to open very slowly, gradually accustoming them to the light. Focus on the first object you see and keep your eyes on this object. Try, once again, to be as objective as you were in your listening and touching. Avoid casting around for something more 'interesting' to look at; instead, remain attentive to the first object you saw, the one which your eyes have chosen for you to look at, and remember the saying, 'if you give your interest to

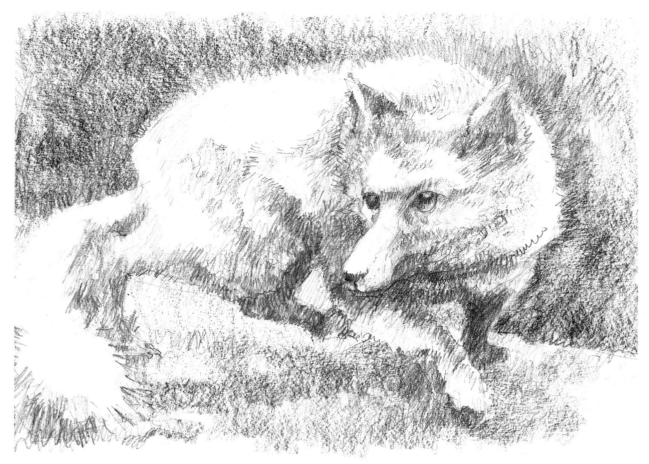

A STUDY OF *THE STUFFED FOX*

something, it will become interesting'. (Boredom, like terror, resides only in the mind.)

Allow your eyes to follow the object's outer contours; let them travel round its edge as you see it from where you are sitting and without moving your head. Look at the *kind* of contour you see and notice whether it is curved or straight or changes from one to the other as your eyes travel round the perimeter. Look also at the *changes of direction* of this contour as your eyes travel round it. Notice how sometimes it is inclined towards the vertical, sometimes towards the horizontal and at other times it is inclined at varying angles.

Now look at what are known as *tonal values*. 'Tone', 'value' and 'tonal value' are terms that refer to the range from light or pale to dark. Look carefully at your object and notice whether it has some patterning, printing or writing on it. If it has, you may be able to notice how some parts may be paler or darker than other parts. Now look carefully at your object again and see how daylight or lamplight falls on it. Notice how the

parts that catch the light are paler compared with those parts which are in shadow. You have detected the two reasons for the variety of tonal values which are there for you to see. Finally, look at the *colour* of this object. If it is multi-coloured, select one of its most prominent colours. (If it appears to be of an 'insignificant' colour, such as beige, brown, grey, black or white, be not perturbed! We shall soon be learning how such 'neutralities' can be considered as all part of our coloured world.)

In order to assess the particular *hue* of this colour, which is the word to describe the 'colour' of a colour, it is helpful to select another object, or part of another object, nearby, which is of the same main colour category, and then to compare the differences or similarities between the two hues. Do so by moving your eyes from one object to the other so that you can detect even a slight difference between the two hues. For example, the colour of the object which you chose originally may be green. By comparing it with the

colour of the object you choose next, you may be able to detect that it is quite clearly a yellow-green as opposed to the blue-green of the second object. As another example, a white object may appear very slightly yellow, like the colour of cream, compared with another object which appears 'cool', as if it were very lightly tinged with blue. Yet another example, which may take a little practice to detect, is the variety of hues seen in the colour black.

John Ruskin said of Diego Velasquez, 'There is more colour in his black than most painters have in their palettes.'

You have now completed your first practice of the Golden Cord. I hope you enjoyed it and found it enlightening. If you have never practised such an exercise before, just try a few minutes to begin with, and then extend the period as your concentration develops. At first you may find that your mind wanders. Sometimes it appears, quite wilfully, to travel anywhere of its own accord! Do not worry unduly about this and avoid reprimanding it and its apparent waywardness at all costs. When you notice that it has gone away on its own little 'trip' somewhere, simply and gently direct it back on course again. We have already noted how the mind is continuously active; in order for it to be calmly attentive it needs to be helped and nurtured by a gentle discipline such as this exercise. With daily practice you will notice – indeed, you may well already have noticed – how wonderful is the natural operation of the senses. Moreover, how wonderful it is to be aware of them working each in turn by disciplining the mind to attend to them in this way.

The eye that sees is the I experiencing itself in what it sees. It becomes self-aware, it realises that it is an integral part of the great continuum of all that is. It sees things such as they are.

FREDERICK FRANK

In medical circles, various forms of such an exercise are practised more and more, and are becoming accepted as genuine methods to relieve stress, promote healing and generally encourage well-being. In religious circles, the exercise is as old as the religions themselves. In the West it is known as contemplation; in the East it is known as meditation. You may be interested to know that I first learned the rudiments of the exercise from a Benedictine nun, Sister Columba, who called it prayer. It was she who first gave me the opportunity to understand that drawing need not only be my career, pleasant and important as it is, but also my way of discovering the world around me and a way of discovering myself.

In this light, drawing suddenly became more important and simultaneously more pleasant. It could become, if I so chose, my form of prayer. It certainly is my form of devotion. Drawing, be it for profit, an absorbing hobby, or an occasional pastime, can impart these same rewards to anyone – it may also do so for *you*. Whatever words you use to describe such absorption of your mind (homage, devotion, calling, career, fun) the enjoyment, pleasure and sense of wonder is available to all. This is what Sister Columba believed about the importance of *painting* for me. It can apply equally to *drawing* for you:

There is no sin in painting if that is what your instinct draws you to do all the time. Both painting and looking, especially when you understand what kind of 'subjects', have that deep close affinity to contemplative prayer. They are both means of opening a door, not on to wishful thinking but on to realities not accessible by less reflective and absorbed means. Prayer follows on contact with these realities, whether it is contact within a mass of poppies or those white daisies.

SISTER COLUMBA, OSB

CHAPTER TWO

Exploring the nature of materials

We may very well suppose that, by 'the works of nature', Sir Philip Sidney was referring to such natural phenomena as trees, fields, mountains and rivers. However, this phrase can equally well be applied to the materials with which we draw, since paper and pencils also derive from nature.

As with all nature's goods, our materials should be treated with due respect. They are there neither to be dominated by us, nor to intimidate us. How strange that the inoffensive items used to compile a shopping list can overwhelm us with fear when they become the dreaded tools for that terrifying activity of drawing!

Let us find out exactly what the nature of our materials, and ourselves are capable of. Prepare yourself by practising the Golden Cord exercise so that you become attentive and relaxed at the same time. Try to maintain this condition throughout the next activity.

THE SENSITIVITY SHEET

Clip a sheet of A4- or A3-sized white paper to a drawing board and sharpen a couple of pencils; start with an H and a 2B. This sheet of paper will now be referred to as the 'sensitivity sheet' because it is by this very sheet of paper that we shall be learning amazing things 'through the gate of sense', as Jean-Jacques Rousseau said. Place an upright chair about three feet away from your table. Sit down and place the drawing board between you and the table so that the upper part

of the board, on which the paper is clipped, is resting on the edge of the table and the lower part of the board is somewhere between the centre of your thighs and your knees. The board can be either vertical or horizontal and its angle can be anything between 10° and 90°. In fact, when you practise this next activity try as many variations as possible; you could even try moving the chair and board further away from the table so that your arm has the freedom to move easily.

Stretch out the arm and the hand with which you normally write, and move the four main joints: the knuckles, the wrist, the elbow and the shoulder. Move them in turn and watch how they can each move independently of the others. Take one of the pencils, hold it in any way you like, allow the point of the lead to touch the paper and, without predicting, watch your knuckles move the pencil for a few seconds and allow the marks to appear on the paper. In other words, be concerned with the *process as it happens* rather than predicting the result. Only when you finish the movement permit yourself to look at the result.

When you do so, examine the marks objectively, almost dispassionately, but none the less meticulously. Observe the variety of direction, type, possible tonal differences and even variations in the width of the marks. The direction can vary in inclination from horizontal to oblique to vertical. The type of line can vary from straight to curved. Tones can vary from light to dark, and although the width of the marks may not vary greatly, the variation is there to be seen if you choose to look for it. Once more we are giving the kind of relaxed but attentive interest we have just practised in the Golden Cord .

Now stretch out the same arm, grasp the same pencil, but this time allow the pencil to be moved

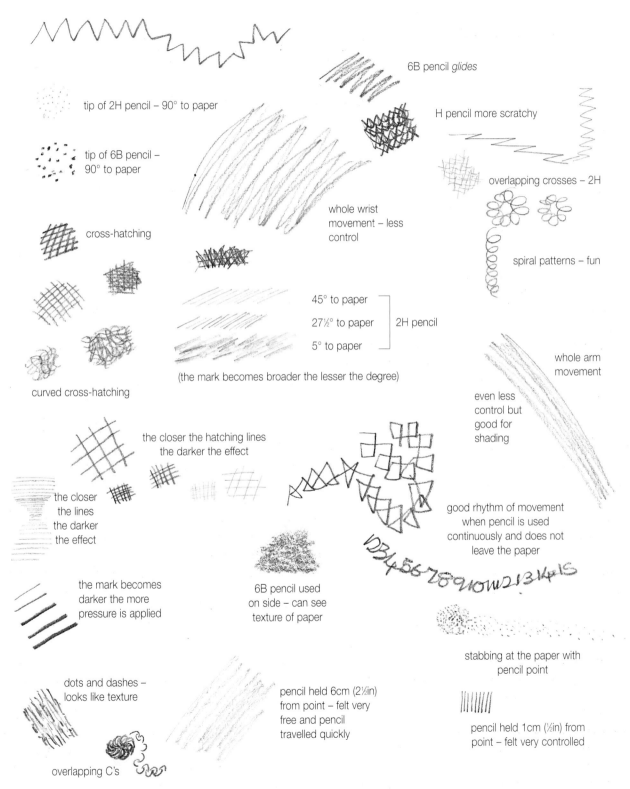

knuckle only – felt jerky but controlled

6B pencil *glides*

tip of 2H pencil – 90° to paper

H pencil more scratchy

tip of 6B pencil – 90° to paper

overlapping crosses – 2H

whole wrist movement – less control

cross-hatching

spiral patterns – fun

45° to paper

27½° to paper] 2H pencil

5° to paper

whole arm movement

(the mark becomes broader the lesser the degree)

even less control but good for shading

curved cross-hatching

the closer the hatching lines the darker the effect

the closer the lines the darker the effect

good rhythm of movement when pencil is used continuously and does not leave the paper

the mark becomes darker the more pressure is applied

6B pencil used on side – can see texture of paper

stabbing at the paper with pencil point

dots and dashes – looks like texture

pencil held 6cm (2½in) from point – felt very free and pencil travelled quickly

pencil held 1cm (½in) from point – felt very controlled

overlapping C's

A SENSITIVITY SHEET BY LOIS THWAITES

by your wrist, and instead of *watching* your arm joint moving the pencil, close your eyes and *listen* to the sounds on the paper as they occur. Once again, but with *another* of your senses, you are concentrating on the process *as it happens* rather than predicting the result. After a few seconds stop and then examine the marks in the same objective and careful way as you did before.

Now move the pencil with your elbow and then with your shoulder. During both activities apply the same kind of attention with either your sight, or your hearing, or your sense of touch to the process as it happens. Indeed, you could proceed with each of these two activities three times: *watch* the action of your arm the first time, *listen* to the qualities of sounds which arise from the contact between the pencil and paper the second time, and during the third time *feel* the pencil in your fingers and notice the various kinds of vibrations which are caused as the pencil travels over the paper. At this stage only when each individual activity is finished may you permit yourself to examine what has occurred on the paper.

The point of the exercise is that only by such experimentation and examination may we begin to understand the real significance in what we do and what has been achieved by others. Look at the copy of *Madonna with the Fruit-Plate* by Leonardo da Vinci, observing particularly the type and quality of lines made. Observe, objectively and dispassionately, the enormous variety of length, width, tone, direction and even distance between the lines (the Mozart 'silences'). It is in this way that we can really appreciate the power and magnificence of such truly wonderful works. We are really seeing the *extraordinary* in the *ordinary*. Then, suddenly, we notice that Leonardo has given the child several legs! No doubt the child did not sit still for long and Leonardo has drawn all the positions of those fidgety legs. Furthermore, he has *allowed* all the different positions to *remain* in this drawing. What would *we* have done if we superimposed one such leg over another? 'Rubbed them out!' is the usual response when I ask this question of a group of students who, by the tone of their answer, have already understood that to do so would be to destroy not only a record of knowledge achieved over a period of time, but also a cunning device which represents movement, activity and animation.

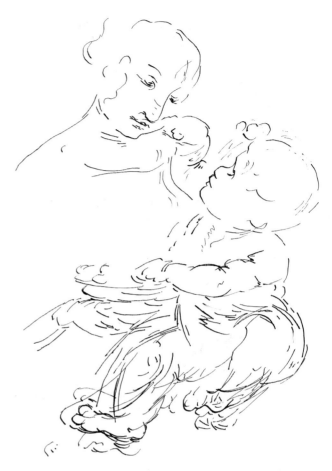

A COPY OF *MADONNA WITH THE FRUIT-PLATE*
by Leonardo da Vinci (original: The Louvre, Paris)

In this delightful drawing Leonardo da Vinci has, as it were, given us permission to preserve, keep and even treasure what we might once have considered, although erroneously, a mistake, because what we might ignorantly judge as incorrect may, indeed, not only be correct, but also contain a *number* of valuable, purposeful and expressive qualities.

In the introduction, we noticed how even young children seem to be filled with wonder when they are completely absorbed in an activity whereas adults seem to find this state difficult to regain. Nevertheless, it is not impossible.

I first used this method of exploring drawing materials with primary school children who, as you can imagine, practised their sensitivity sheets without preconceptions but with ease and enjoyment. This did not preclude their being serious and sensible; they even wrote comments about their discoveries.

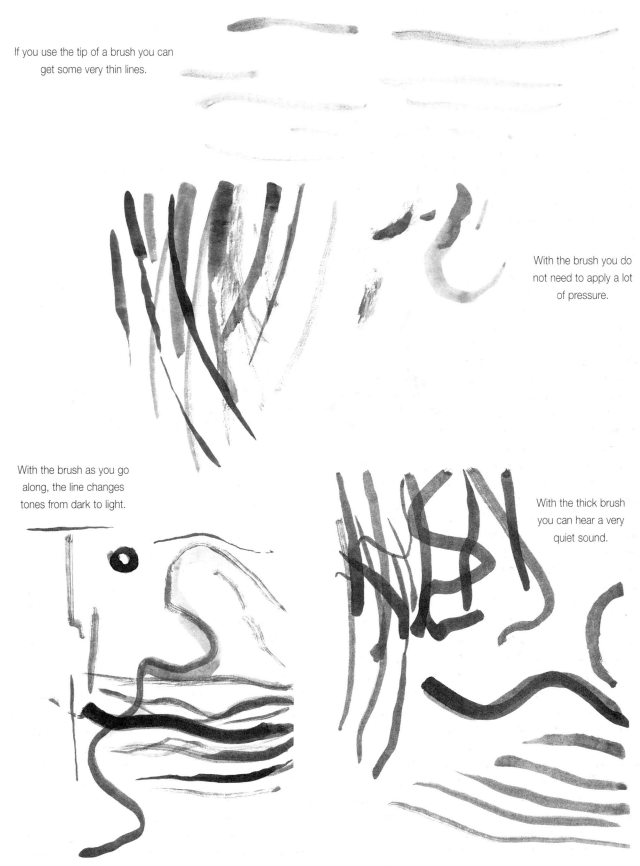

If you use the tip of a brush you can get some very thin lines.

With the brush you do not need to apply a lot of pressure.

With the brush as you go along, the line changes tones from dark to light.

With the thick brush you can hear a very quiet sound.

REPLICATED DETAILS OF A SENSITIVITY SHEET AS A CHILD DREW AND WROTE IT

Here are some examples of children's remarks on their sensitivity sheets:

What they heard
With the thick brush, you hear a very quiet sound.
The thin charcoal makes a higher sound than the thick charcoal, but it makes a lower sound than the chalk.
When you use this brush, you can't hear anything.

What they felt
With the brush, you don't need to apply a lot of pressure.
The charcoal is hard to put on chalk.
The harder you press on your pencil, the more control you've got.
Soft pencil runs smoothly along the paper.

What they saw
If you use the tip of a brush, you can get some very thin lines.
With the brush, as you go along the line changes tone from dark to light.
If you draw with charcoal and then draw on top with a pencil, the charcoal seems to disappear. Then if you smudge it, it comes back.
Even when you draw with the thin charcoal lightly, you get a thick dark line.
When you go another way, the line changes in thickness.

I could have filled this whole book with just the children's sensitivity sheets! However, I have exercised discipline and allowed myself just a few details to show you, and the examples of their comments above. One of the most perceptive remarks came from a child who was comparing two marks which were not dissimilar to those illustrated at right. If we look first at the marks themselves (which are labelled '4B' and '2H') we might, at first glance, dismiss them as mere scribbles or insignificant doodles. However, the child's response was not so dismissive! He wrote: 'Very different; 2H is rougher and lighter and makes a quite deep indentation on the paper, even though it was on the side of the pencil. The 4B is very black but leaves a lot of white paper showing through because it is so soft.' It is clear that the child's objective sensitivity had become so highly developed that he was acutely aware not only of the nature of the lead but also of the paper. Furthermore, he was aware of the interaction

between the paper and the pencil and, moreover, he was equally aware of the exact role he had to play in order for this interaction to occur. Here, truly, is an example of 'achievement' and 'success' which arises out of the ability to focus on the process of an activity.

What the child did not know at the time was how the artist Georges Seurat achieved a similar effect. At right is a freehand copy of one of his studies for the large painting called *Bathers at Asnières*, which hangs in the National Gallery in London. He has used very rough paper, like watercolour paper, on which he has employed a wax-based crayon. His subtle handling of the crayon has allowed the tiny indentations of the paper to remain white, thus imparting beautiful subtlety to his tonal values.

Now that I have, I hope, persuaded you that there is not only a great deal of importance and purpose in exploring the nature of materials in this way, but also that it is great fun to do, return to your drawing board and practise the sensitivity sheet activities again. Take up your pencil again and allow marks to appear on the paper by moving the knuckles, the wrist, the elbow and the shoulder each in turn. You can make each of these movements three times, employing the senses of sight, touch and hearing individually as described on page 18. Each time, if you are truly attentive,

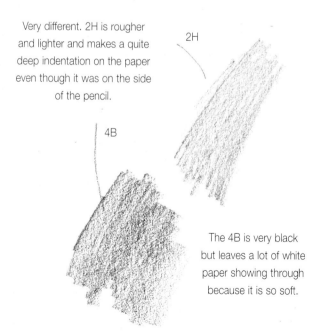

Very different. 2H is rougher and lighter and makes a quite deep indentation on the paper even though it was on the side of the pencil.

2H

4B

The 4B is very black but leaves a lot of white paper showing through because it is so soft.

REPLICATED DETAIL OF A SENSITIVITY SHEET AS A CHILD DREW AND WROTE IT

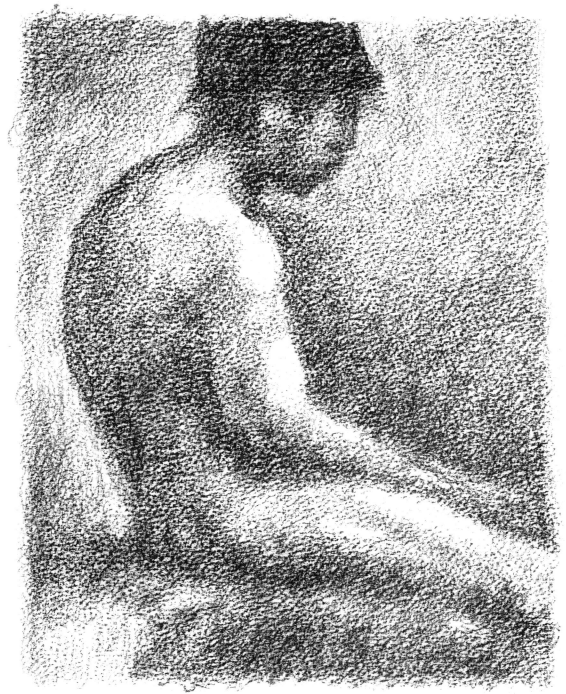

A COPY OF A STUDY FOR *BATHERS AT ASNIÈRES*
by Georges Seurat (original: National Gallery, London)

you will notice different things. At first these may not seem to you to be very significant but, as I am sure you are beginning to realise, it is important not to dismiss such observations, however slight, but to accept them as true knowledge. Indeed, write them down, as my young pupils did. Note your observations immediately after making each mark. Avoid making several different marks in quick succession. It is all too easy to get carried away when we really get into the swing of things, the mind working overtime, and, in our haste, we concentrate only on what we want to do next, forgetting almost everything we have done before and how and why we did it! Avoid this by pausing for reflection upon and examination of each mark you make, and by writing down something about it.

Decisions to make before each mark:

1 Choice of pencil to use, eg 2B, HB, 9B, etc
2 Choice of arm to use, ie left or right
3 Choice of arm joint, ie knuckles, wrist, elbow, shoulder
4 Choice of grasp, eg between first two fingers and thumb or within whole fist, etc
5 Choice of where to hold on 'shaft' of pencil, eg close to lead, other end or somewhere in between
6 Choice of pressure of grasp, eg loosely or tightly
7 Choice of angle of pencil, eg vertical, obliquely, etc
8 Choice of position on paper, eg left, centre, above, etc
9 Choice of direction of movement, eg up, down, sideways, etc
10 Choice of type of movement, ie straight or curved
11 Choice of speed, eg slow, fast, moderate, etc
12 Choice of duration, eg long, medium, short, etc
13 Choice of which sense to bring to the attention, ie sight, hearing, touch

Examples of thirteen decisions made
before each mark are as follows:

1 4B
2 Right
3 Knuckles
4 Between first two fingers and thumb
5 This is the one variable for all thirteen decisions. The pencil will be held close to the lead at the start and be held further away for each subsequent mark
6 Moderate
7 Vertical
8 Right of centre
9 All directions
10 Curved
11 Moderate
12 Short (two or three seconds for each movement)
13 Touch

Observations:
Resulting marks are smaller and darker when pencil is held near lead. They become larger, paler, sometimes broken and seemingly 'uncontrolled' when the pencil is held far away from the lead.

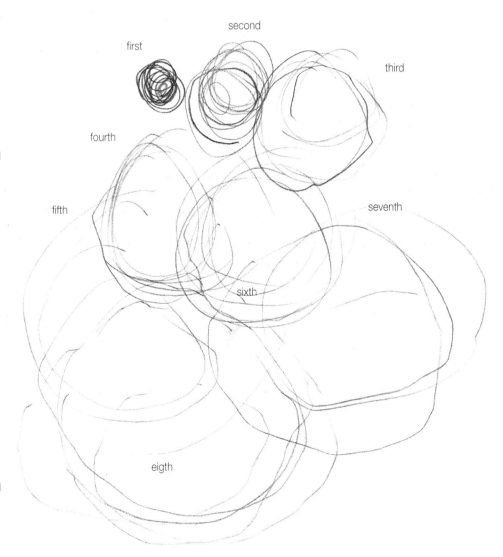

A SENSITIVITY SHEET WITH THIRTEEN POSSIBLE DECISIONS TO TAKE BEFORE MAKING A MARK,
AND AN EXAMPLE OF EACH OF THE THIRTEEN DECISIONS WITH OBSERVATIONS
ON THE ENSUING ACTIVITY

In the illustration opposite are listed some of the many and varied decisions there are to take *before* making each mark. At first these may seem daunting to you. Try to avoid such debilitating thoughts and simply proceed through the instructions as if you were reading a route map before embarking on a journey. Indeed, the analogy of a journey is not inappropriate – we have already referred to this book as your 'voyage of discovery'. Remember, though, that even the most familiar journey is never the same twice. Events and circumstances provide a constantly changing environment all around us. The driver of a motor vehicle must be constantly alert to such changes in order to avoid danger. Furthermore this kind of awareness also enables us to appreciate the ever-changing world around us, and to portray it in our drawings.

Take a fresh sheet of A3 paper (or two sheets of A4 side by side). On one half, list the decisions that are required *before* making each mark. Compare your list with the one opposite. You may well have thought of more variables than I have.

The diagram below this first list shows the completed sensitivity sheet. Notice how each of the eight marks is determined by all thirteen of the prior decisions listed next to the diagram. Notice also that the only variable is where the pencil was held along its shaft, and how this single variation makes such an enormous difference in the qualities of each mark, especially in determining its size and tonal value.

On the other half of your A3 sheet, try such an experiment yourself. You will be amazed at the enormous variety of marks that you can achieve

by following this relatively easy discipline. Remember that such a discipline of pre-planning is not the same as prediction: whatever occurs on the paper will often surprise you. Paradoxically, discipline is an agent for freedom.

Now that you have discovered this fact you could try several more sensitivity sheets, using different pencils and different kinds of paper. Explore not only the nature of the various materials, but also your ability to concentrate on the process of what you do as you do it. Examine and assess what you have done and exactly how you did it. If you do this in an objective and careful manner, you will not only release yourself from the shackles of negative self-criticism, but also gain the freedom and confidence to ascend to the heights of dispassionate objectivity. Then you are within reach of true wonders!

*The weight of sadness
was in wonder lost.*

WILLIAM WORDSWORTH

The sensitivity sheets shown in this chapter demonstrate the results of complete absorption, and real enjoyment in that absorption on the part of both adults and children. Allow them and the exercises in this chapter to inspire your experimentation. Indeed, why not resolve to develop your sensitivity sheets as part of your daily routine? Not only is this a pleasant way to spend half an hour, but you will also increase your skill and self-knowledge with each passing day.

Chapter Three

Exploring the nature of perception

We have now arrived at a point in our voyage of discovery together when we need to investigate how we perceive the world around us.

We are about to engage in two exercises. Both should be rather amusing to do, but both also hold a crucial key with which you may unlock a very special door to reveal all those 'secrets' of drawing generally, and incorrectly thought to be available only to the gifted few.

These two exercises are derived from a wonderful book called *Drawing on the Right Side of the Brain* by Betty Edwards, which not only demonstrates how everyone is *capable* of drawing but also shows you how to *learn* to draw.

Read the following instructions and proceed with each exercise in turn. We shall then discuss their purpose in full and examine how they relate to the nature of perception.

EXERCISE 1:
THE UPSIDE-DOWN DRAWING

Prepare yourself by practising the Golden Cord exercise so that you become alert and attentive but also calm and relaxed at the same time. Now clip an A4 sheet of paper, positioned vertically, at the top of your drawing board. Place the bottom of the board between your lap and your knees and allow the top of the board to rest on the edge of the table. Sharpen a 2H pencil ready for action. Now look at the upside-down and extremely simplified version of a drawing of a Madonna by Raphael (left). Place this illustration near your A4 sheet of paper so that you can see both easily.

Begin by looking at the upside-down drawing. Note that the whole is really an arrangement of various kinds of individual lines. Choose one of these lines and notice whether it is long or short and whether it is straight or curved. If it is straight, ask yourself in what direction it is travelling in relation to the edges of the paper: vertically, horizontally or at an oblique angle? If the line is curved, is it an open curve or a rather closed curve? Does your chosen line touch or overlap another line? If it does not touch or overlap another line, how far is the distance between it and the next line? Now examine the nature of the lines lying to the right and left of 'your' line, and the lines lying above and below it. In this way

**AN UPSIDE-DOWN COPY OF A DRAWING
BY RAPHAEL**
A very simplified version of an unidentified female saint
(British Museum, London)

24

you will be *seeing* the drawing in terms of what it is rather than *understanding* it in terms of what it represents. If you now turn the drawing the right way up it is more difficult to see the lines as lines because the mind almost insists on translating the lines *as a face* with features.

Turn the drawing upside down again and start drawing the lines as you actually see them in terms of their relative length, direction and type. Try to draw each line in the position on the paper as you see it in the illustration. Try also to assess the distance between the lines and their particular relationship with each other and draw them in the way you have just assessed them.

Keep drawing in this way. Above all, avoid naming the parts of the face, like 'nose' or 'eyes'. If you do, there is a serious danger that you might terrify yourself and start thinking, 'I really can't draw noses and eyes!' and, indeed, stop drawing altogether. Therefore, avoid conjuring up any unnecessary 'giants' and continue to draw the lines as lines and nothing else. This is a simple exercise in perception; just draw the lines as you see them.

Although it is important to make every attempt to be accurate in your drawing, do not be over-concerned if you do not record every line as accurately as you might wish. Avoid, at this stage, erasing and re-drawing any of your lines by keeping your attention on the line that you are drawing *now* rather than worrying about the one you have just drawn. At this early stage of our 'voyage of discovery' it is far more important to *be* drawing, however 'inaccurately', rather than to be continually correcting. 'Accurate' drawing will occur by dint of much practice just as other disciplines and areas of knowledge require practice to develop the fluency of your skills. Therefore, be gentle with yourself and continue to draw at a regular and easy pace. As well as looking carefully at what you are doing, try also to remember to listen sometimes to the sound of the pencil and, at other times, to feel its touch as it travels across the surface of the paper. In this way it is likely that your 'voyage' becomes pleasurable and certainly interesting because, quite simply, you are giving your interest to it. Continue in this manner until you draw the very last line in your first attempt at this exercise.

Now turn both drawings the right way up.

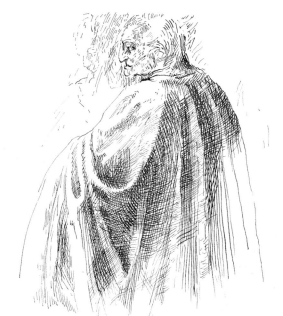

A copy of a drawing by Michelangelo

His copy of figures from a fresco by Masaccio
(original: Albertina, Vienna)

A copy of a drawing by Michelangelo

His study from an antique sculpture (original: The Louvre, Paris)
Both illustrations employ a cross-hatched technique with remarkably different effects. This is caused by the variety of the lengths of the lines, the distances between the lines, and whether the lines are curved or straight.

Compare them with each other and immediately feel pleased with yourself for actually having made the attempt to draw a head! Maybe you have not drawn all the lines exactly as they are in the illustration, but never mind! This is your first attempt and you need to congratulate yourself on how you have managed to record all the information as accurately as you could. You will be able to assess positions and proportions a little more precisely each time you practise this exercise.

When students attend my *Drawing for the Terrified* classes, I give them this drawing hidden in an envelope. They gradually pull the drawing out of the envelope and draw the lines just as they appear. It is usually only when the eyes emerge that there are reports of sudden horror as the students realise they are drawing something they 'cannot draw'.

You could ask a friend to put a simple line drawing in an envelope for you to draw in this way. You could even prepare one for your friend so that you can compare your reactions and results together. Give it a try; it is great fun to do.

When you have practised this exercise with simple line drawings a number of times, try more complex drawings like those illustrated on page 25. Then choose some with a variety of tonal values and eventually try coloured drawings. This is a useful way of learning how other people respond to the world around us which, in turn, helps us in our own learning and development.

EXERCISE 2: PROFILES

Start, as always, with the Golden Cord exercise so that you are sitting comfortably and your mind is calm but attentive. Clip a sheet of A4-sized paper, vertically positioned, to the top of your drawing board. Place the bottom of the board somewhere between your lap and your knees and allow the top to rest on the edge of the table. Sharpen either a 2H or a 2B pencil (it does not matter which one you use for this exercise). Read all the instructions for the *whole* of this exercise before you do it: these are contained in the next two paragraphs.

First of all, imagine in your mind a human

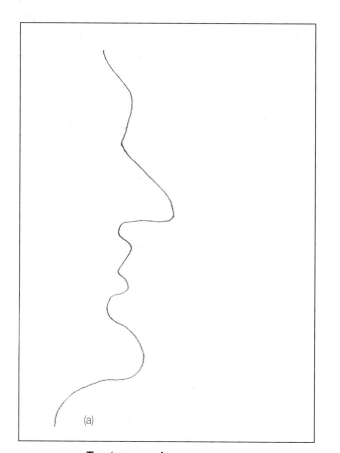
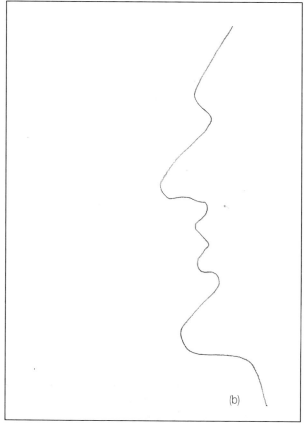

THE 'IMAGINED' PROFILE FOR THOSE WHO DRAW WITH THE RIGHT HAND (A) AND THE LEFT HAND (B)

profile. *Think* of the forehead, the brow, the eye-socket, the nose, the upper and lower lips, the chin and the neck. Now draw this *imagined* profile on the left side of the paper, facing towards the right. (If you are left-handed, draw the profile on the right side of the paper but facing towards the left.) The diagrams below left illustrate both alternatives. However, when you come to do the exercise, do not copy the illustration because it is important to *imagine* your *own*, otherwise the purpose of the exercise will be missed. As you draw *your* imagined profile, *name* each part of the face as you draw it. Say to yourself silently in your mind, 'forehead' as you draw the forehead, 'brow' as you draw the brow, 'eye-socket' as you draw the eye-socket and so forth, so that you are thinking of the names of the features as you draw them each in turn until you finish the drawing with the neck. Do not pause in the drawing but proceed to draw one continuous line which starts at the top of the paper and finishes at the bottom.

When you have finished drawing your first imagined profile, look at it carefully and draw it on the other side of the paper but facing the opposite way. Draw it as you see it this time rather than as you think it. (You drew your first imagined profile as you *thought* it: it was therefore a conceptual drawing. This second profile is to be a *perceptual* drawing.) This time, rather than thinking of the features, be aware only of how you have to estimate the particular contours of the line: its various angles, lengths and directions. In order to follow these instructions easily you must follow one more all-abiding instruction. This is to focus your eyes and your mind only on the first profile as you draw the second one. (You will still see the line that you are drawing, but only in your *peripheral* vision.) This requires from you a huge act of faith, as it has done from all students who have attended my *Drawing for the Terrified* courses. Many students who try this exercise are unable to do it at the first attempt because they succumb to the extremely strong temptation to shift their focus of attention from the first profile, even if only for a moment, to the action of the copy they are presently drawing. Instantly they report that there is a terrifying hiatus! Some cannot continue at all, while some can continue only hesitantly. However, those who permit themselves to follow the instructions verbatim, invariably report that they found the exercise so easy that it was almost miraculous, but also that it demanded this 'act of faith'. All, however, with practice have eventually been able to perform the exercise illustrated.

Now see how you manage it yourself. Do not worry if you are 'successful' or not yet. Remember 'achievement' is not nearly as important as observing yourself travelling. Try it a few times. Then, and only then, read on.

THE UPSIDE-DOWN DRAWING AND PROFILES EXPLAINED

Embodied in these two foregoing exercises is the most important, indeed crucial principle for perceptual drawing, that is: drawing what is *seen*, as distinct from conceptual drawing, which is: drawing what is thought or known. The brain is divided into two parts, or as they are more properly known, two hemispheres. Each hemisphere has a different way of functioning, and the simple diagram shown on page 28 illustrates their main functions. It is the left hemisphere that directs

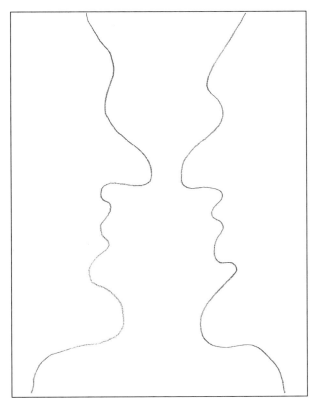

A DIAGRAM DEMONSTRATING BOTH THE DRAWN 'IMAGINED' PROFILE AND ITS PERCEIVED REPRESENTATION DRAWN IN REVERSE

LEFT	RIGHT
Verbal	**Non-verbal**
Using words to name and explain	Being aware of things without using words...
Digital	**Non-digital**
Using numbers	... or numbers
Logical	**Analogical**
Using a step-by-step approach to draw conclusions	Non-verbally metaphorical and representational
Sequential	**Spatial**
Using a step-by-step approach to draw conclusions	Understanding of relationships
Analytical	**Holistic**
Understanding details	Understanding the concept of the whole
Rational	**Intuitive**
Explaining by reasoning based on facts, data and evidence	Understanding by instinct and insight
Temporal	**Non-temporal**
Understanding time	Being unaware of time

A DIAGRAM DEMONSTRATING MEDICAL SCIENCE'S PRESENT UNDERSTANDING OF THE SPECIAL AND PARTICULAR FUNCTIONS OF THE LEFT AND RIGHT HEMISPHERES OF THE BRAIN

conceptual drawing whereas the right hemisphere directs perceptual drawing.

Look at the diagram again and you will see that the left hemisphere understands words, sequences, numbers and time. It functions logically, analytically and rationally. The right hemisphere is complementary. Its understanding is not in words, sequences, numbers and time; rather it functions spatially, holistically and intuitively. We shall discover that this right hemisphere also understands colour and tonal values as they are perceived.

There is an interesting and extremely important phenomenon concerning our 'management' of these two hemispheres, which is not always understood at first: we are unable to access both hemispheres simultaneously. When we access the left we cannot access the right at that time. Similarly, when we access the right we cannot access the left at that time. Because messages are received by the brain with such incredible frequency and rapidity, we have the *impression* of *simultaneous* understanding. However, the *fact* remains that this is alternate. We can put this to the test immediately by looking again at the illustration on page 27. At *one* time you understand that you see two profiles looking at each other with a 'space' in between them. At another time you can see an elaborate vase with 'spaces' either side of it. Can you see them simultaneously? No, you have to admit that you are unable to do so. However, you will notice that you can shift attention rapidly from one to another, but you cannot understand both representations of the profiles and the vase simultaneously. There is another way of understanding this drawing and it will be easier for you to understand this way if you turn it upside down. Do this now and 'see' the drawing simply as two lines with three 'spaces' which represent neither the profiles nor the vase but are simply lines or an abstract pattern. It is possible to turn the drawing the other way round again and to 'see' the drawing in this way. Try it and observe yourself shifting your attention among these three ways of understanding, each separate from the others. Your perception of the drawing in terms of an abstract pattern is understood by your *right* hemisphere, because you see it without naming it and holistically: you accept it for what it *is* rather than for what it represents. Your *left* hemisphere understands the drawing in terms of either the profiles or the vase because you have named them and you are focusing on a part of the drawing and consequently allowing the rest of the drawing to be the background or, as we have described it, the 'space' or 'spaces'.

Note that not only are you able to access only one hemisphere at a time, but also that you can focus on only one message through that hemisphere at a time (the vase or the profiles). Furthermore, we are able to focus on only one message arriving through only one sense channel at a time! Do you remember how, when you were exploring the nature of the pencil and the surface of the paper with your sensitivity sheets in Chapter Two, you discovered that at any one time you were capable only of listening or of touching or of looking at what was happening? The word *focus* is important. Try an experiment now. Sit in a room where you hear a continuous sound like a clock ticking or the drone of distant traffic. Take up a pencil and start tapping it on the table. Allow your mind to focus on the tapping of the pencil. As you do this you can still be *aware* of the ticking of the clock or the drone of distant traffic. It is, as it were, 'in the background'. Now reverse the situation. Allow your mind to focus on the ticking of the clock or the drone of distant traffic. As you do this you can still be aware of the tapping of the pencil but now it is 'in the background' of your attention. You may be aware of several sensory inputs, but you can only focus on one at a time. This is just a brief synopsis of the very complex functioning of the two hemispheres of the brain as it is understood today. If you want to know more I suggest you read Betty Edwards' book *Drawing on the Right Side of the Brain*, in particular the first few chapters, but the brief discussion above should be sufficient for our present purpose. Think back to when you performed the 'upside-down' drawing. If you followed the instructions of drawing the lines as lines, you were being directed by your brain's right hemisphere. If, at any time, you thought of any of the features and felt impeded, you were being directed by the left hemisphere.

Read again how my students responded when they had the drawing hidden in an envelope from the start. They began by not knowing what the lines represented at all, and therefore had no

choice but to draw the lines as lines, long or short, straight or curved. They were being directed by their right hemispheres. At some point, usually when they reached the eyes, many realised that the lines they were drawing represented the features of a face. At that moment they switched to being directed by their left hemispheres because they had 'named' it! Some became terrified, their immediate reaction being, 'I can't draw faces!' At that very moment, their left hemispheres were performing logically and rationally (albeit negatively and, as they were soon to discover, erroneously) and telling them all about their inabilities! Equally logically, however, their left hemispheres soon reasoned that, having managed to get this far without trauma by just looking at the lines as lines, there was no reason why they should not continue. At that point their left hemispheres reasoned with them to return to their right hemispheres. Of course, some students continue the exercise from start to finish without 'seeing' the face until they turn the drawing round. It would appear that they have the advantage of being directed by their right hemispheres throughout the exercise.

If you think back to your performance of this exercise, you should be able to recall shifting from one hemisphere to the other, perhaps a number of times, throughout the whole time it took you to do the drawing.

Once again, allow me to remind you that, at this very early stage of your learning to draw, it really does not matter how 'well' or how 'badly' you copy the lines. Far more important is how aware you are of what is directing your performance. This is all part of the process of learning, in this instance the process involves your awareness of your alternate access to the left and right hemispheres of your brain.

Let us now return to how you performed the profiles exercise, paying specific attention to your awareness of your left and right hemispheres functioning alternately. When you drew the first 'imagined' profile and were naming each imagined feature as you drew it, you were being directed by the left hemisphere. When you drew the second

profile, which you remember was an observed copy of the first profile in reverse, you would have been directed by your right hemisphere... if you managed to do it! Many students report an inability to do the second part of this exercise until after much practice and only when they were alone. As I mentioned earlier, it takes an act of faith to follow the instructions to the letter. However, when this is done, the ensuing ability to draw the profile in reverse seems almost miraculous because it is so easy.

How did you manage it? Could you draw the second profile in reverse? Did you become aware of the resistance caused by the doubting left hemisphere which logically, rationally and reasonably is telling you, 'This is difficult to do. Let's name all the features again, it's easier that way. Go on, no one will know you're cheating.'? Did you also notice that the left hemisphere could also say, 'Just look all the time at the first line which you drew, keep your mind all the time on that line, follow these easy instructions...'? As your left hemisphere persuaded you to shift to your right hemisphere, did you *then* notice that words disappeared from your thinking process and were replaced by non-verbal awareness of the kind of line with its various angles and directions on which you were focusing, and that your hand was copying because you were really and truly seeing what you were looking at?

It is worthwhile trying both these exercises again, particularly the upside-down drawing with the variations I mentioned on page 26. As you practise them, become more and more aware of how you access the right and left hemispheres of your brain. As you become more aware of what is happening, you will become aware also of how you are actually in control and can, with practice, direct which hemisphere is to operate the appropriate tasks to be performed.

It is the right hemisphere that will perform the perceptual drawing tasks for you, so it is important to nurture it gently and carefully. If the left hemisphere invades with discouraging protestations, then you must allow your right hemisphere to comfort you with serenity.

Shading; creating tonal values

Practise the Golden Cord exercise, as you have done before, so that you are relaxed and attentive simultaneously. Then clip some fresh sheets of A4- or A3-sized white cartridge paper to your drawing board and sharpen three or four different kinds of pencil. Perhaps you could include a couple more, one which is much harder and the other much softer than your original H and 2B pencils, such as a 4H and a 4B.

Proceed to experiment with all four pencils, each in turn, and do so in the same way as you did with your sensitivity sheets in Chapter Two. In fact, this is another series of sensitivity sheets, but ones which concentrate more specifically on tonal variations and how to create them (see pages 32–3). Tone, as we have discussed before, refers to the range between paleness and darkness. Pale or light tones are sometimes called tints. Dark tones are sometimes called shades.

Now try one or two of these sheets and remember to write notes as you proceed. Your left hemisphere consolidates your right hemisphere's understanding and vice versa. In this way you will notice how both hemispheres complement each other. When you have practised on at least two sheets of paper, read on.

Look again at the sensitivity sheets on the following pages. Compare these with your practice

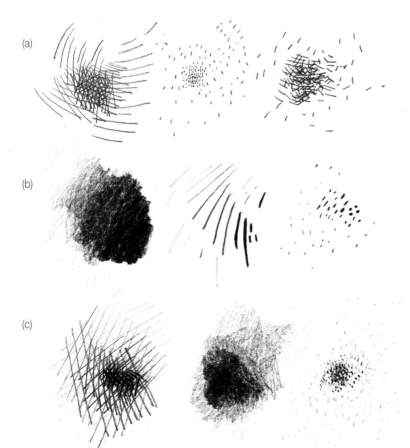

(a)

(b)

(c)

In (a), whereas the tonal values of the marks are all the same, the difference between paleness and darkness is achieved by varying the distance between the marks. In (b) the difference between paleness and darkness is achieved by how little or how much pressure is used on the pencil. In (c), the difference in tonal values is achieved by combining both these processes.

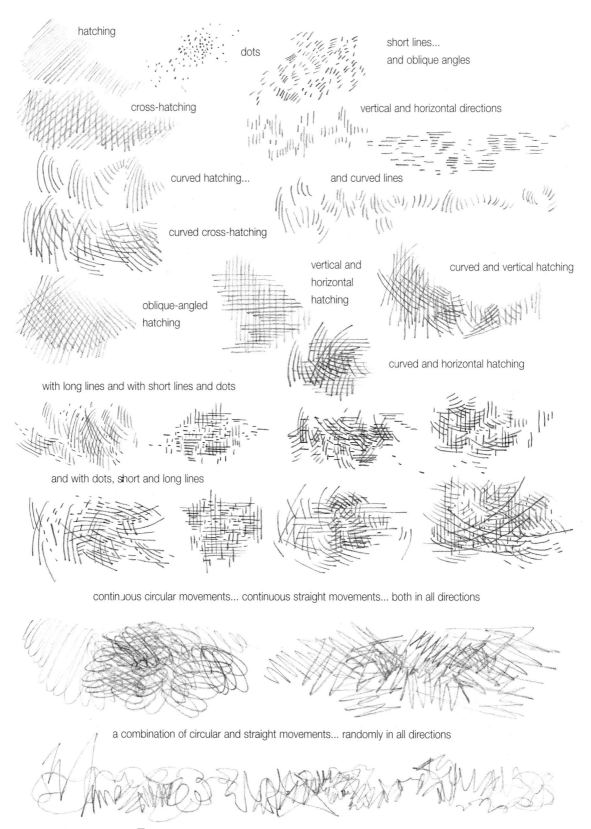

hatching

dots

short lines...
and oblique angles

cross-hatching

vertical and horizontal directions

curved hatching...

and curved lines

curved cross-hatching

vertical and
horizontal
hatching

curved and vertical hatching

oblique-angled
hatching

curved and horizontal hatching

with long lines and with short lines and dots

and with dots, short and long lines

continuous circular movements... continuous straight movements... both in all directions

a combination of circular and straight movements... randomly in all directions

TONAL VARIATIONS MADE WITH THE TIP OF THE PENCIL LEAD

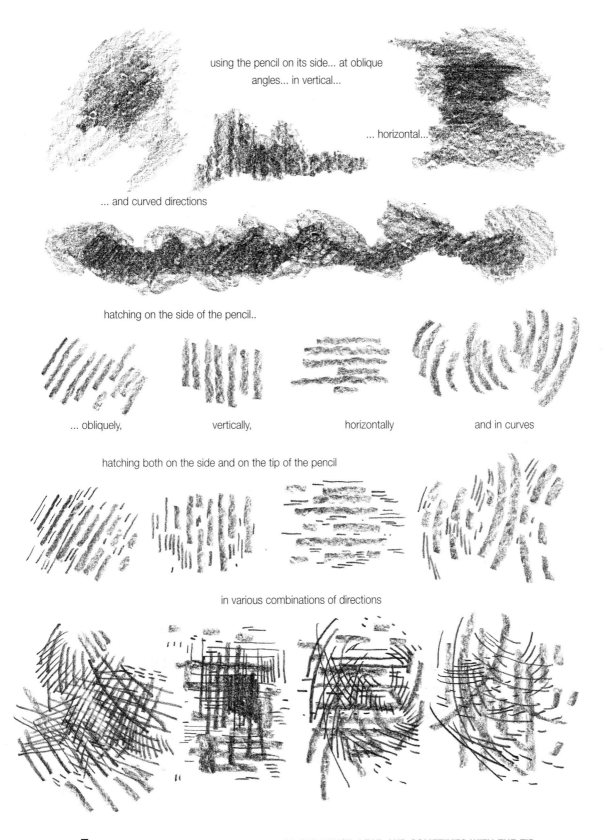

using the pencil on its side... at oblique angles... in vertical...

... horizontal...

... and curved directions

hatching on the side of the pencil..

... obliquely,

vertically,

horizontally

and in curves

hatching both on the side and on the tip of the pencil

in various combinations of directions

TONAL VARIATIONS MADE WITH THE SIDE OF THE PENCIL LEAD AND SOMETIMES WITH THE TIP AND SIDE OF THE LEAD TOGETHER

sheets. Notice how differences of tone are achieved by two main processes, and also by combining these two processes. One of these is how distant or close is the placing of the marks; the other is how little or how much pressure is exerted on the pencil as it travels over the surface of the paper. Try now making such differences in tone by using both methods, separately and combined, and then read on.

'TONES WITHOUT TEARS'

Practise once again the Golden Cord exercise and then pin an A4-sized sheet of paper to your drawing board. Make sure you sit comfortably with your board somewhere between your lap and your knees, and sharpen a 2B pencil in readiness. You are now going to follow a precise and exact procedure of shading which will enable you to make a number of tones from pale to dark with ease and distinction.

Steps one and two
First, draw any small shape, such as a rectangle or a circle, no more than 50mm (2in) high and wide in any direction, somewhere on your sheet of paper. Divide this shape into nine sections. Choose one of these sections and mark it with the number '1' as you see in Step one (opposite). Then shade very lightly all of the sections except that which you have marked with the number '1'; this you leave the white of the paper (Step two). To help you, try holding the pencil very lightly at the end furthest away from the lead. Allow the

Previous pages:

Various directions of marks produce different effects. Some series of marks are composed of groups of parallel lines; this way of shading is called 'hatching'. When two or more different directions of lines in any one group overlap we call it 'cross-hatching'. Both illustrations show how vertical, horizontal and obliquely angled hatching each have different characteristics and how they vary depending on whether the lines are straight or curved, and whether or not they overlap each other in various combinations. Notice also the differences when the lines are long, medium length or short, whether they are thick or thin or whether they are even and regularly controlled or seemingly irregular and random. An enormous number of very different effects can be achieved by very simple means.

movement to come from your wrist and *listen* to the quiet sound of the pencil as it travels gently over the paper. Allow the pencil to travel across the demarcation lines between the sections; this will help you to keep your shading even. You will also see there that the shading marks go over the edges of the rectangle. This is not a colouring-in book! You do not have to stay within the confines of your perimeter.

Step three
Choose one of the sections which you have just shaded and mark it with the number '2'. Leave this and section '1' as they are, and shade the remaining seven sections as you did before. To help you, try holding the pencil further down its shaft and a little more firmly. The very fact that you are putting another layer over the first will darken the tone because this is one of the ways of making the marks more dense. However, exerting a little more pressure on the pencil itself will guarantee the desired effect. Thus you notice that you are combining both processes of shading that we discussed earlier. Including the white section, you have made three tones already.

Steps four to nine
Continue to shade by this procedure. At each stage choose one more section to mark with the next number. Leave all the numbered sections as they are. Shade the remaining unnumbered sections together as if they were one whole shape by allowing your pencil to travel across the demarcation lines between the sections. As before, this will help you to keep your shading even. You can exert a little more pressure on the pencil at each stage until you reach the ninth and, for this time, the darkest tone. You can see the nine stages developing from start to finish opposite.

Now look at *Variations of 'Tones without Tears'* (page 36) which shows a number of variations of this same procedure of shading using different techniques and styles. Draw other shapes on the same sheet of paper and try different techniques yourself. Try using just the side of the pencil and then just the tip. Try cross-hatching with one and just dots with another. Combine two or more pencils and sometimes increase the number of sections in your shapes. You could even try using different drawing media such as charcoal or ball-

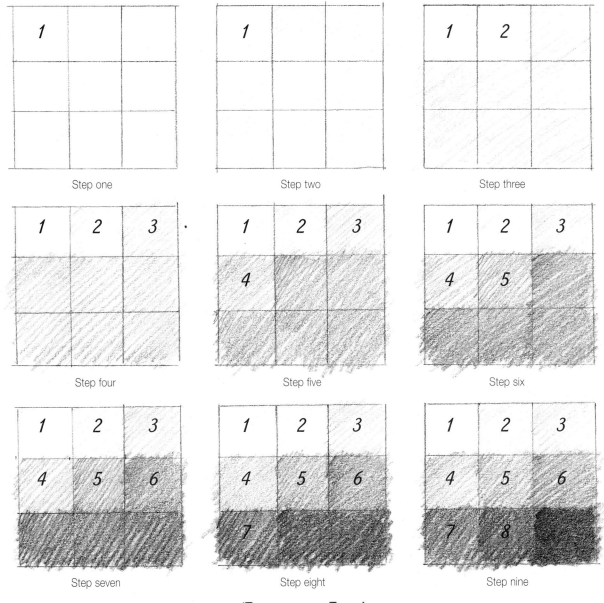

'Tones without Tears'

point pen. This 'tones without tears' procedure of shading from lightness to darkness by this gradual means governs all the subsequent exercises in the book. The more you practise this procedure the more you will learn on your 'voyage of discovery' and the more confident you will become. Allow your left and right hemispheres to 'tell' each other this splendid news!

Confidence placed in another often compels confidence in return.

LIVY

'TONES WITH TEARS'

The next exercise, which also concerns the making of tonal values, is called 'tones with tears' because it is rather less easy to accomplish than the previous one.

Step one
Draw nine squares linked together to form a horizontal line, numbered with the words from 'one' to 'nine' as shown in the diagram on page 37. Leave the square on the extreme left white and mark it below with the number '1'. This indicates that you have dealt with this square first. Then

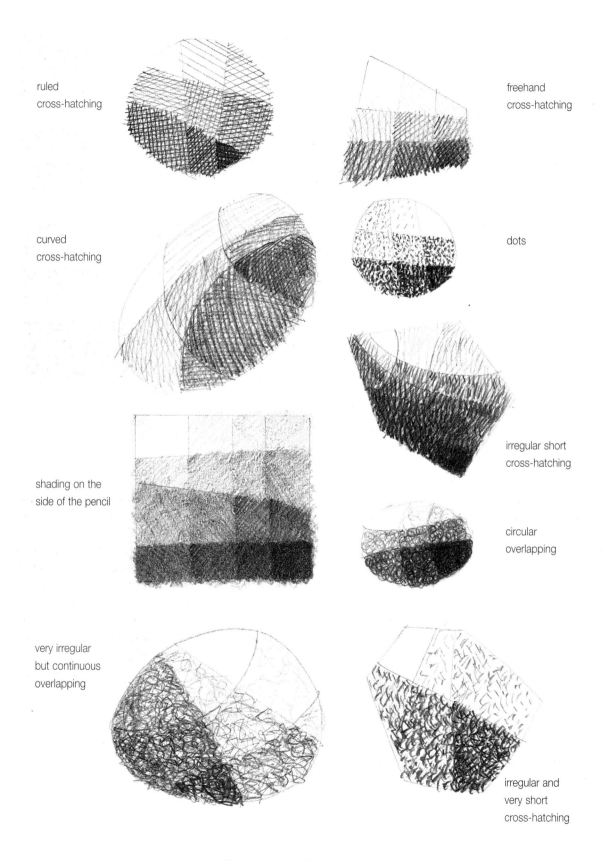

ruled
cross-hatching

freehand
cross-hatching

curved
cross-hatching

dots

shading on the
side of the pencil

irregular short
cross-hatching

circular
overlapping

very irregular
but continuous
overlapping

irregular and
very short
cross-hatching

VARIATIONS OF 'TONES WITHOUT TEARS'

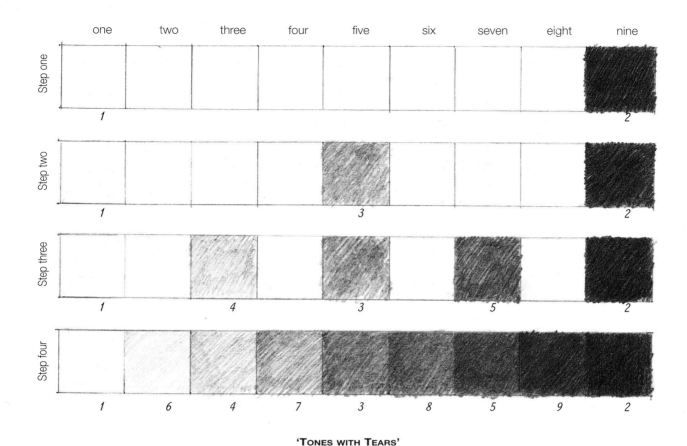

'TONES WITH TEARS'

shade the square on the extreme right, above which you have already marked 'nine' and shade it the darkest tone that you can manage with a 2B pencil. Mark it below with the number '2'.

Step two

The next square to shade is square 'five', which is halfway between those you have just dealt with. You now have to estimate its relative tonal value which is midway between white and black (it does not matter how 'well' or 'badly' you manage). When you have shaded this square, mark it below with the number '3'.

Step three

Next, shade squares 'three' and 'seven'. Once again you have to estimate their relative tonal values. When you have shaded them, mark them underneath with the numbers '4' and '5'.

Step four

Finally, shade the squares marked 'two', 'four', 'six' and 'eight'. Try, as before, to estimate their tonal values relative to those on either side of them. Write '6', '7', '8' and '9' underneath them.

This exercise is both very useful and very difficult. You should practise it much later on, after you have completed all the other exercises in this book. The only reason for trying out such a difficult method at this stage is to show you, by comparison, the relative ease of the previous exercise. You will therefore be delighted to learn that, henceforth, 'tones without tears' is the procedure to be favoured.

For not to live at ease is not to live.

JOHN DRYDEN

CHAPTER FIVE

Simple monochrome drawing

It is in order to really see, to see ever deeper, ever more intensely, hence to be fully aware and alive that I draw what the Chinese call 'the ten thousand things' around me. Drawing is the discipline by which I constantly rediscover the world. I have learned that what I have not drawn I have not really seen, and that when I start drawing an ordinary thing I realise how extraordinary it is – sheer miracle.

FREDERICK FRANK

We now come to the point in the book when we begin to record on paper what we perceive in the actual world around us. Start by practising the Golden Cord exercise again in order to expel any 'giants' and to become calm, peaceful and serene but also, at the same time, bright, alert and prepared to concentrate in a relaxed manner. It is time to attempt our first still life.

PREPARATIONS

Spread out a few oranges, apples, onions, tomatoes and two or three grapes on the table before

THE VIEWFINDER

you. Keep your arrangement simple. You will find, as you have found before, much to interest you in seemingly 'uninteresting' and simple things simply by giving your interest to them.

Simplicity is not an end in art, but one arrives at simplicity in spite of oneself, in approaching the real sense of things. Simplicity is complexity itself and one has to be nourished by its essence in order to understand its value.

CONSTANTIN BRANCUSI

Adjust your viewfinder (see page 10–11) to an inner size no larger than 100mm by 150mm (4in by 6in), and use it to frame part of your still life.

The diagram at right shows you how to prepare your sheet of paper. Clip an A4-sized sheet of paper to your drawing board, sharpen a 2B pencil and have a ruler and putty rubber near you. Draw a rectangle at the top of the paper which needs to be of the same *proportions* as the inner rectangle of your viewfinder, but not necessarily the same *size*. (In fact, if you draw it exactly the same size you may find it too small and somewhat confining. My preference is to make it a little larger.) Mark on all four sides of this rectangle the half and quarter points. In this way your drawn rectangle is a scale replica of the inner rectangle of your viewfinder in terms of its *proportions* and the 'map reference' marks. A little way above this rectangle draw another rectangle about the size of a postage stamp and divide it into nine parts. This is going to become another 'tones without tears' exercise, which will be done concurrently with the drawing and will act as a guide and show you how to proceed. Clip also to your drawing board one of your previous sheets of paper on which you experimented during the 'tones without tears' exercise. This is your 'crib sheet'!

Now position yourself and the board comfortably so that you are ready to draw. You may need to adjust the viewfinder's position. Remember, you do not have to see all of the still-life group; the viewfinder selects part of the whole.

Take some time and trouble over your preparations. There is no rush. Pay attention through any of the appropriate senses so that you may enjoy the whole process to the full.

1: First rehearsal: draw all the main contours on the 'glass' in your viewfinder (15–20 seconds).

2: Second rehearsal: draw all the main contours on the 'glass' in your viewfinder and relate them to each other in terms of their position and size (25–30 seconds).

3: Third rehearsal: draw all the main contours on the 'glass' in your viewfinder and relate them to each other and to the map reference points on your viewfinder (30–35 seconds).

4: Dress rehearsal! draw all the main contours in the air a few millimetres over the rectangle on the paper. Count four-four time. Keep the eyes on the subject for the counts of one, two and three, and on the paper only on the count of four (35–40 seconds).

Step one: First performance!
Act 1: draw all the main contours within the rectangle on the paper with pale and broken lines. Keep counting four-four time so that you may follow the discipline of looking mostly at the view rather than at the paper (2 minutes).

PREPARING THE SHEET OF PAPER FOR DRAWING AND THE FIVE INSTRUCTIONS TO HELP YOU SEE WHAT YOU ARE LOOKING AT: YOUR 'REHEARSALS' AND THE 'FIRST PERFORMANCE'

Genius is the transcendent capacity of taking trouble in the first instance.

THOMAS CARLYLE

Check once more that you have taken up a comfortable position and try to keep your head perfectly still so that your 'view' remains constant.

It is useful and somewhat comforting to have a few trial runs to start with, rather like rehearsals for a play. In fact, the analogy to theatre is favoured by many of my students. The emphasis on 'play' helps to lighten their hearts without in any way lessening or trivialising the seriousness of their activity. Suddenly, the anxiety and the solemnity is removed! So we shall employ the analogy now and maintain it throughout the exercise.

Read instructions 1 to 4 on this page and Step one opposite before you start drawing so that you understand the sense of what to do as a whole. It would help you to write down the gist of these instructions just below your rectangle on your sheet of paper, as you see illustrated on page 39. Then read all five instructions again so that your left hemisphere is fully aware of what to do and thus mollified and 'silenced', enabling you to be guided by your right hemisphere. This is the only way for you 'to really see' and to draw what you see.

1: First rehearsal

Take the pencil in your normal drawing hand and extend your arm to its full length so that the pencil lead touches the viewfinder. Pretend that there is glass in your viewfinder, and make as if to tap on this with your pencil lead. Now 'trace' on the 'glass' all the main contours or edges that you see in your 'view' (you may find it helpful to close one eye as you do this). This will include the edges of the fruit and vegetables, and also the edges of shadows, reflections and a possible change in colour or tone within one of the objects. For example, an apple may have a distinct change of colour and tone from pale yellow to dark red across its surface. This distinction becomes one of your 'main contours' because you see that distinction clearly. If you do not see changes of colour or tone clearly because they are so similar or change only gradually, then you do not indicate them. You draw only those that are *obvious*. Hence these are your *'main contours'*.

In this first rehearsal, take no more than twenty seconds to 'draw' on the 'glass' in your viewfinder all such main contours. Just notice that they are there. Do not rush or dither, just try to work efficiently at a moderate pace.

2: Second rehearsal

This second rehearsal is very similar to the first. Its purpose is to make you more aware of how the contours relate to each other. In order to realise this effectively, focus your attention on each contour as you trace it on the 'glass' in your viewfinder and also compare its size and position to the one that you have just traced. Very deliberately, notice whether each contour is higher or lower than the last, and to the right or to the left of it. As you continue, you will discover that you can compare each contour with several others. Furthermore, you can gauge each contour's straightness or curvature relative to others and you will also notice that you can 'measure' their particular directions.

3: Third rehearsal

This third rehearsal, once again, complements the first and second. However, this time you should note the *length and position* of each contour relative both to the other contours *and* to the 'map reference' points on your viewfinder. This assists in locating particularities within the context of the whole composition.

4: Dress rehearsal

This rehearsal gives you the opportunity to practise the very action you will need to perform in order to draw on the paper, but without actually making any marks. Hold the pencil just a few millimetres over the rectangle you drew in the 'Preparation' stage and perhaps try counting to four repeatedly. Counting regularly and evenly sets yourself a rhythmic pace. For the counts of 'one', 'two' and 'three' keep your eyes on the 'view' in your viewfinder, but at the same time allow your pencil to 'draw' by its following your eye movements. On the count of 'four' you may, if you wish, glance at the rectangle on the paper to check that the movements you are 'drawing' in the air just over the paper correspond with your eye movements. As you practise this you will see your pencil movements in relation to the rectangle *in your peripheral vision*, very much as you did in drawing the 'profiles' exercise. The focus of your attention is the view in your viewfinder. The movements of your hand are informed by the subject. If you allow this to happen, your rehearsal will take care of itself.

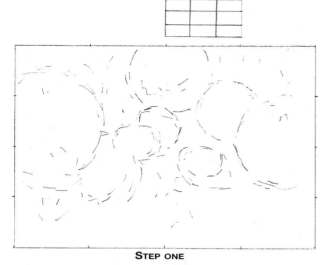

STEP ONE

Drawing your main contours with pale and broken lines.

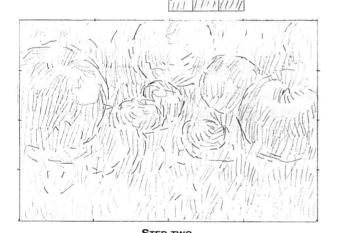

STEP TWO

Drawing the first shading stage and adjusting the contours.

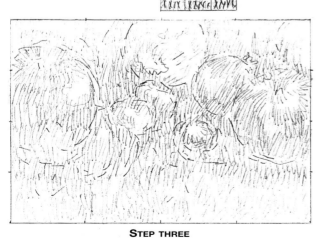

STEP THREE

Drawing the next shading stage and adjusting the contours.

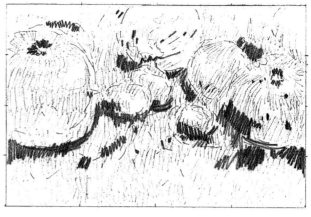

THE 'CURRANT BUN' SYNDROME!

Step one: First performance – Act 1

Proceed now as you have done with all the rehearsals. Allow your eyes to follow the main contours of the 'view' in your viewfinder. As you do so, relate them to each other and to 'map reference' points on your viewfinder. As you do this, allow your pencil to follow your eye movements and also allow the pencil to touch the paper. You are actually drawing now! However, keep the lines pale and broken, since dark and continuous lines would be difficult to amend. Pale and broken lines can be changed if necessary without first having to erase them. These initial marks, whether accurate or not, are vital because they are your guides for ensuing marks. Step one shows how several broken lines in varying positions together as a whole describe the contours which are seen in the 'view' through the viewfinder.

It is very important to look at the 'view' more than you look at the paper. Thus, for the present time, you might continue to try counting or just *humming* at a rhythmic pace so that you create a discipline to follow. Without such a discipline the temptation to look too often at the paper *could* be irresistible.

What the eye can see the hand will draw.

MICHELANGELO

Michelangelo's statement is not the truism it might appear at first reading. The emphasis is on

41

the word 'see'. Hitherto, most of us have only glanced at the world around us. Now we are training ourselves to look with relaxed attention and with easy intensity, and by such means our hands will draw what our eyes see.

Now re-read sections 1 to 4 and Step one, and follow them before reading on. Remember, you should be both relaxed and attentive throughout.

Step two: First performance – Act 2

After you have drawn all your main contours with pale and broken lines, put the pencil down and give yourself a well deserved rest! If you are feeling at all tense or anxious, repeat the Golden Cord exercise.

Take your pencil to the little rectangle which has been divided into nine sections. Choose one of these sections to leave as the white of the paper and shade all the other eight sections very lightly. When you have done that, give yourself another rest and understand that, in principle, what you have just done is what you are about to do at the next stage in your drawing. You are to find the palest parts of your subject, leave them as the white of the paper, and shade all the rest very lightly.

The viewfinder tends to throw shadows on the subject. Up to this point it has been a very useful device. However, it is now obsolete, so remove it.

Half-close your eyes and become aware of the variety of tonal values that are discernible within your subject. (Remember that your 'subject' is that part of the entire still-life arrangement which your viewfinder chose.) Determine which parts or areas of the subject you believe to be the palest. These are usually those that catch the light the most. However, it is *your* response that is needed, and *your* selection that matters. Decide which parts or areas you will leave as the white of the paper, and draw very pale and broken lines to indicate their contours. When you have done this, take the pencil and shade all the other parts of the composition very lightly. Allow the pencil to move in different directions so that it describes the forms, directions and apparent 'movements' of all these parts just as your eye sees them: for example, the way you perceive the lines on the onions, the striations on the apples, or the directions of shadows or reflections on the table. If you allow this to happen, your drawing will immediately take on a lively and animated aspect. In order to allow this to happen you must permit yourself to look *at* and *see* such directions and 'movements'. This can still be easily achieved by using the same counting or humming rhythm that you used before, so that your eyes are focused more often and regularly on the subject than on the paper. Allow yourself to respond continually to the subject by means of this easy discipline of looking. You will discover that you are truly drawing what you see because every mark you make constructs the form as a result of your honest response (see Step two). When you have completed this stage, read on.

Steps three, four, five...:
First performance – Acts 3, 4, 5...

When you have completed the first shading stage, you may wish to correct, alter or amend some of the main contours which you began to establish at the start. Because you made these contours very pale and in broken lines they may have merged with your shading marks, so there will be no need to erase them. This method of shading from pale to dark tones means that there is always the opportunity to make as many changes as are needed since everything is relatively pale at every stage. It is also very easy to use your putty rubber at this stage to re-establish any highlights that your exuberant pencil movements may have inadvertently shaded.

Once you have made any necessary amendments you are ready to move on to the next shading stage.

Take your pencil to the little rectangle which you have divided into nine sections. Choose one of the eight sections which you have shaded a very pale tone to remain thus, and shade the remaining seven shaded sections very lightly so that they become just slightly darker than the section which you have just preserved. Refer to the illustration of Step three on page 41 to help you.

Now look at your still-life subject again. Half-close your eyes and determine the next slightly darker tonal value in the arrangement. These are not so obvious to see because what you are *actually looking* at is the very subtle gradation of many tonal values from light to dark. Do not worry; trust in what you see. Hazard an informed guess as you see in Step four. Choose the areas in your subject which appear *to you* to be the next slightly

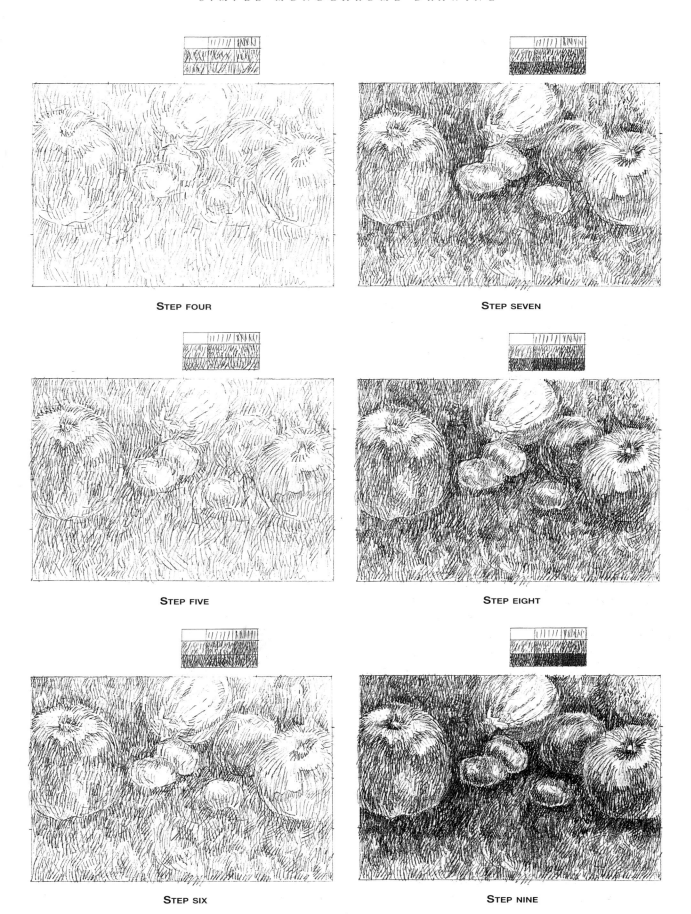

STEP FOUR

STEP FIVE

STEP SIX

STEP SEVEN

STEP EIGHT

STEP NINE

darker tonal value. These are usually, though not always, very near the palest areas which you have just selected. Rely entirely on your perception and proceed as you have done before. Very lightly and gently outline these areas which you have determined as the next slightly darker tonal value with pale and broken contours so that you know where the pencil is now *not* to travel. Then shade the rest of your composition as before in a constructive manner. (Your pencil movements need not necessarily repeat the *same* directions as before; you may well notice *other directions* to be emphasised. Very soon you will discover that everything can appear multidirectional: allow yourself to respond to anything *new* which you notice as the drawing progresses. Once more, let us remind ourselves that this is what drawing from observation is all about!) Look at Steps five to nine, and you will see how the forms in the still-life arrangement *begin* to appear three-dimensional, an effect enhanced by the very slight variation of tonal values which have been realised.

Some students report a strong desire to establish some dark tones at this stage, but there is serious danger that if the darkest areas (in the subject) are established (in the drawing) and made rather too dark at this early stage, the drawing will be thrown completely out of balance as in the example shown on page 41, which looks more like a currant bun than a still life! Remember how difficult the 'tones with tears' exercise on pages 35 and 37 was compared with the gradual progression of our present 'tones without tears' method, which allows you to proceed with comparative ease within its flexible discipline.

Very soon you will appreciate *even more* how the discipline of shading consistently from light to dark gives you the freedom to correct, alter or change your drawing, quite drastically if you wish, without a major 'plot twist'! Just as your pencil corrects, alters and changes, so allow your putty rubber to do the same. Use it constructively to 'draw' the light parts as you have just seen them. Thus it becomes as positive and as purposeful an instrument as your pencil.

It may help to imagine your drawing as a child, growing harmoniously in all parts until it reaches maturity, rather than one section reaching adulthood while the rest remains in baby clothes. Your drawing, be it newborn or fully grown, should be complete at every stage of its development.

No good really leaving one or two areas of ourselves behind and growing in the rest. The neglected ones will at some point come into the foreground and be very noticeable and painful. Then the only thing to do is to accept that they are 'younger' than the rest of us and need to 'be brought up to the level of the rest' as someone put it.

SISTER COLUMBA, OSB

These words of wisdom can equally apply to our drawings. However, do not be *worried* if a part of your drawing should inadvertently be made a little *too* dark or left *too* pale at any one stage. The flexibility of this system of shading allows an appropriate remedy to be administered at once.

Look now at Steps five to nine progressively from start to finish and continue to draw in this way. The number of tones is entirely of your choosing. You will notice that we have already stopped 'numbering' in the little diagram. After all, 'numbering' is the province of the left hemisphere, and we need to function in the right hemisphere. In fact, all we need to know is that each stage wants to be reasonably consistent, and that we are dealing with the next darker tonal value in relation to all the previous stages.

You will also have noticed that drawing is not just 'doing the outlines and then filling them in'! I am sure that you also realise that your attentive consciousness has revealed to you all kinds of possible techniques with which you may interpret your various responses to the subject.

Look now at the next sequence of Steps one to nine on pages 45–6. It shows the same still life drawn using a different technique. The illustrations which you *were* looking at have been drawn with the pencil lead on its tip and with a curved cross-hatched technique, whereas in the second sequence of Steps one to nine shows how the pencil has been used on its side, which has allowed a 'softer' and more blurred effect to occur. The cross-hatched technique is more 'controlled', this technique is seemingly more 'accidental'. You might like to try drawing the same subject using more than one technique, the two (or more) drawings progressing concurrently.

We shall discuss the important benefits of drawing concurrently in the next chapter where

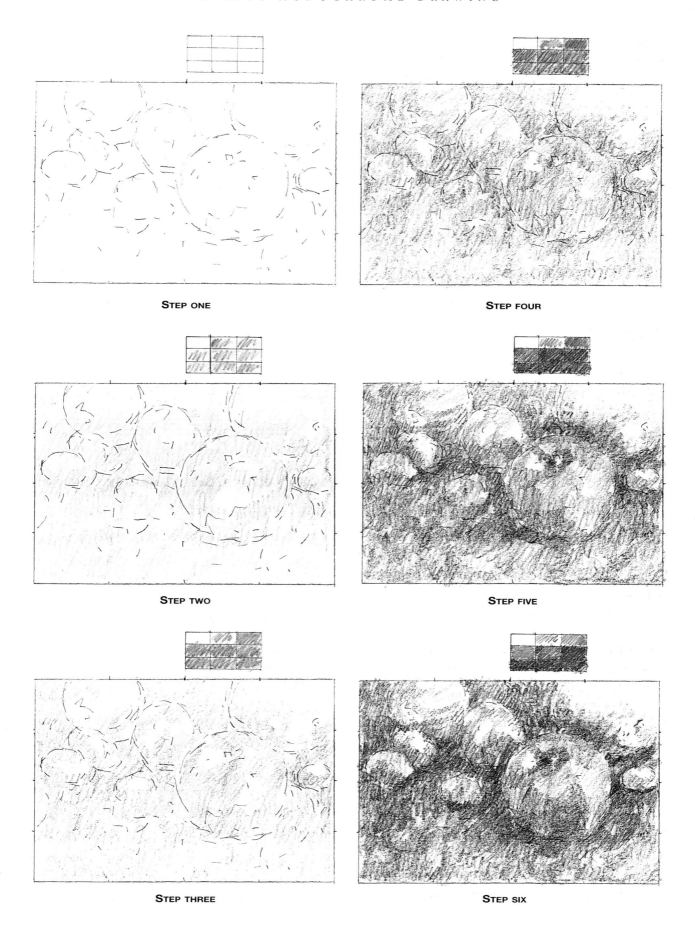

STEP ONE

STEP TWO

STEP THREE

STEP FOUR

STEP FIVE

STEP SIX

45

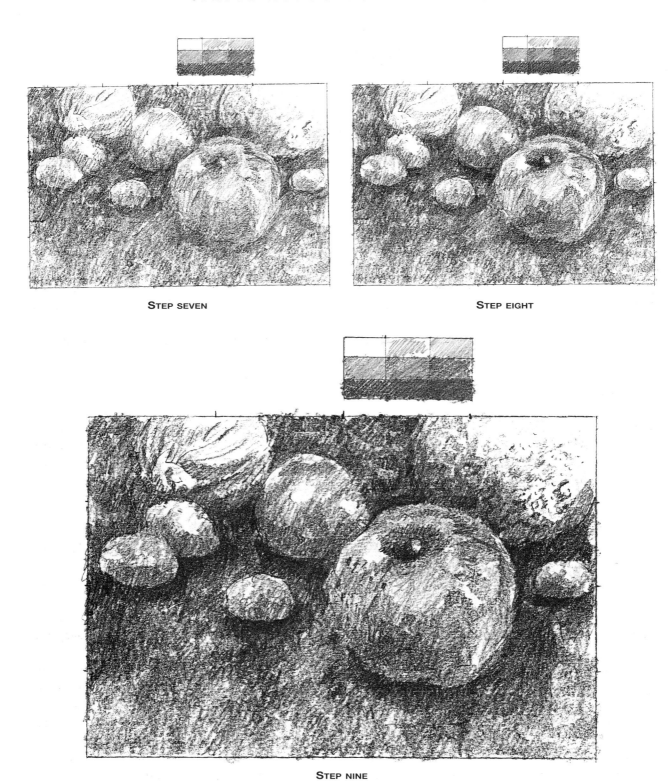

STEP SEVEN

STEP EIGHT

STEP NINE

we shall also discuss and practise other guiding rules. The important thing for now is for you to develop your drawing in a way which *you* think is appropriate. You could develop it so that it is fully 'grown-up', or, if you like, left 'young' but whole and complete at this early stage. The choice is yours. When you have finished your 'first performance', indulge in a well earned rest before you proceed to the next chapter. However, first of all give yourself a standing ovation for your first-night triumph. Because of your courage and determination, our play is set for a long run!

CHAPTER SIX

Rules of the game

First of all, a question: did you enjoy making your very first drawing in the previous chapter? I hope so. Remember that it does not matter whether your drawing is 'successful' yet. Far more important is whether you are beginning to enjoy learning to understand the process of drawing. This is the main reason for the following seven rules for what I shall refer to as our 'games of serious fun' in connection with drawing. Our activities certainly need to be serious but also enjoyable, hence my description of our activities as playing 'games of serious fun'.

Rules are part of the game,
They are not outside it.
No rules: then no game.
Different rules: then a different game.

JOHN DEWEY

Perhaps you may find it rather strange to find such 'rules' being presented to you *after* you have done your first drawing. You will soon realise that you have already been practising most of them; I am really only *clarifying* what you have already been doing.

Rule one – Be restful

Most activities proceed far more smoothly if we approach them in a calm and rested state of mind. 'Problems' become 'opportunities for development' if our attitude is positive. Being rested in mind focuses our energies, whereas being in a rage tends to dissipate them, usually in singularly unhelpful directions, such as the wastepaper basket. Taking 'rests' between activities help us to restore our energies and to reflect constructively on what we have achieved.

Rule two – Be comfortable

This is linked to rule one. If we maintain a comfortable posture, which also keeps us alert and concentrates our energies, we will find that we become more quickly and easily rested in mind and heart as well as in body. The Golden Cord is an excellent facilitator of relaxed attentiveness.

Rule three – Be present

We always live at the time we live and not at some other time, and only by extracting at each present time the full meaning of each present experience are we prepared for doing the same thing in the future.

JOHN DEWEY

Of course, we are always *bodily* present. However, we have already noticed how our minds have a habit of wandering elsewhere. Therefore, we need to take up the point of relevance and propriety – and I use the word 'propriety' quite literally because it refers to what is needed, necessary and appropriate for a particular activity. Relevance and propriety are very important considerations for us when we draw. If we want to draw what we actually see, we must focus both our eyes and our minds on the subject and not on anything else. And in order that our attention is maintained on present activity ('the subject') it has to be guided by the brain's right hemisphere.

Remember the profound words of Jean-Jacques Rousseau: 'Everything that comes to the mind comes through the gate of sense'? Certainly, if we are truly attentive to the operation of our senses, we will be fully aware of what is actually happening in the present. We experienced this when practising sensitivity sheets in Chapter Two.

Those experiences governed all subsequent experiences and they shall govern all our future games.

Shakespeare says, we are creatures that look before and after. The more surprising that we do not look round a little and see what is passing under our very eyes.

THOMAS CARLYLE

Rules four, five and six – Play many games... speedily... and concurrently.
These three rules need to be explained together.

Drawing is a means of finding your way about things and a way of experiencing more quickly certain tryouts and attempts.

HENRY MOORE

We discussed the relevance of Henry Moore's statement in the Introduction and also discussed number, speed and concurrent activities, or, as we now say, 'games'. The fact that you have been drawing since first reading what Henry Moore, John Ruskin and other sages had to say about the discipline of drawing will allow a deeper understanding to grow in your consciousness about their wisdom, and enable you to put their suggestions into practice by, as I have rephrased, 'playing many games, speedily and concurrently', in the exercise which follows.

First, practise the Golden Cord exercise so that you become outwardly calm and inwardly serene but at the same time alert and attentive. Set up a still-life group rather like the one you arranged in the previous chapter, again using your viewfinder (although you could vary the size or proportions if you wished).

Clip an A3-sized sheet of white paper to the top of your drawing board. Also clip to your drawing board one of your previous 'tones without tears' sheets so that you may refer to it throughout the whole of the forthcoming game. Sharpen two pencils. Try the 2H this time as well as a soft one like the 2B or even a 4B. Have a ruler and the putty rubber nearby on the edge of the table within your reach.

This time draw *two* rectangles side by side at the top of your sheet of paper. Again make them the same proportion as the inner rectangle of your viewfinder but not necessarily the same size. You could, if you wish, make them each a different size. Mark the half- and quarter-point 'map references' as you did before, and above each rectangle draw another rectangle about the size of a postage stamp and divided into nine parts. You are now ready to have two attempts at drawing the same still-life group.

If you look at Steps one to eight progressively you will see how two drawings of the same still-life group have been developed concurrently. In a very real sense they are my records of what Henry Moore described as 'a way of experiencing more quickly certain tryouts and attempts', as well as finding my way about things.

As each stage of one drawing was completed, I then proceeded with the same stage on the other. I also chose a slightly different view of the same still-life group for each besides this and I attempted two different techniques: I used a curved cross-hatch technique for the drawing on the left, and a technique which involves the juxtaposition and proximity of dots for the drawing on the right. Notice also that the technique in each of the smaller rectangles corresponds with the drawing below it. If you look carefully at the start of each drawing (Step one) and compare the initial marks there with the marks in the completed drawings (Step eight) you will see that the *tone* of the actual marks are the same; the illusion of tonal gradation in both drawings is achieved by the proximity of the marks. If you turn back to page 34, you can refresh your memory about how the difference between paleness and darkness is achieved by the relative intervals between the marks. This is also clearly shown in the illustration on page 31.

Try two drawings yourself and work them concurrently. Remember that this does not mean simultaneously! Recall our discussion about our being capable of *focusing* on only *one* thing at a time. Therefore, while you are attending to one of your drawings, you are unaware of the other. So that you are not tempted to let your attention be distracted, cover the drawing which you are not developing with a sheet of paper while you are drawing the other. Only at the end of each stage

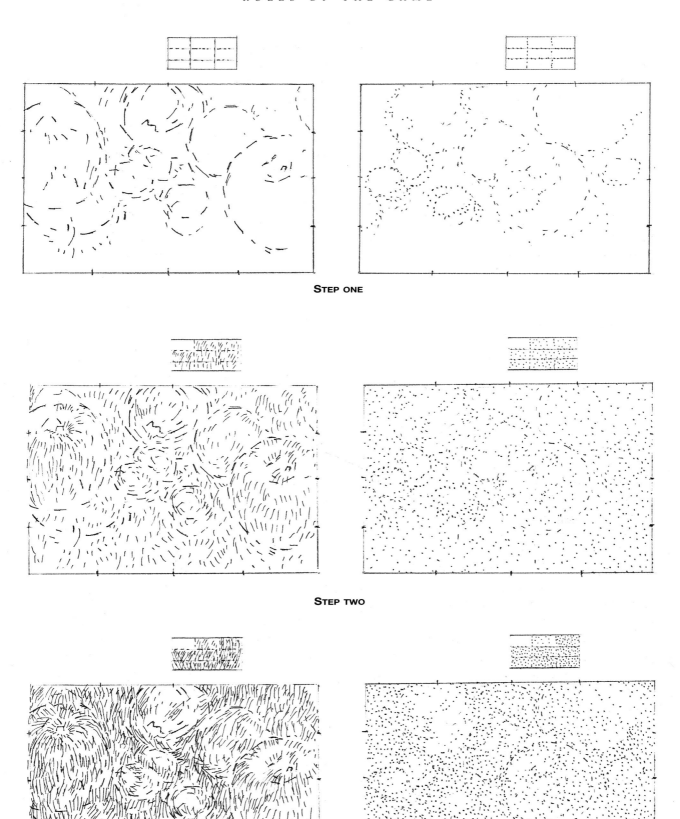

STEP ONE

STEP TWO

STEP THREE

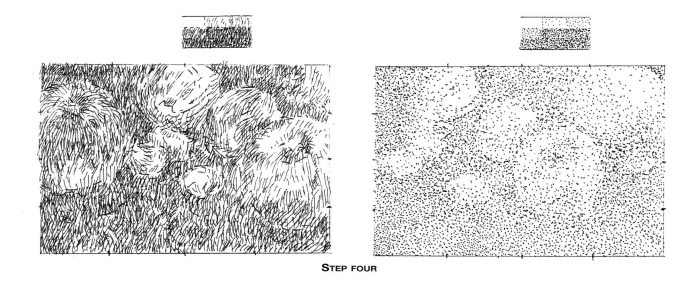

STEP FOUR

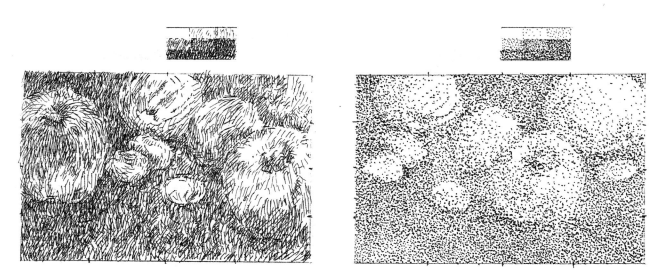

STEP FIVE

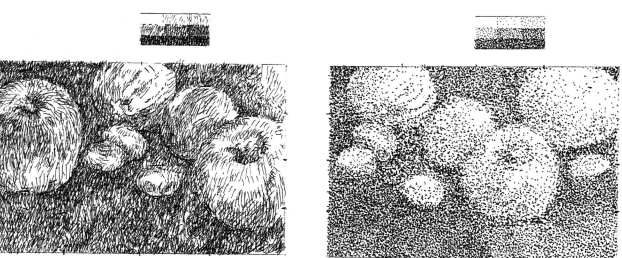

STEP SIX

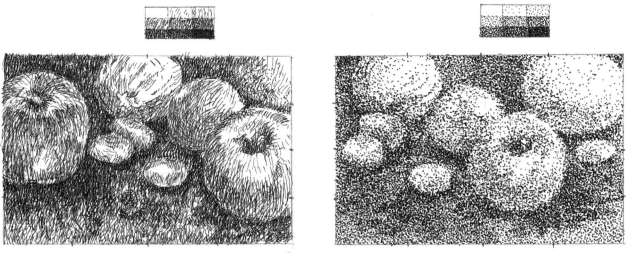

STEP SEVEN

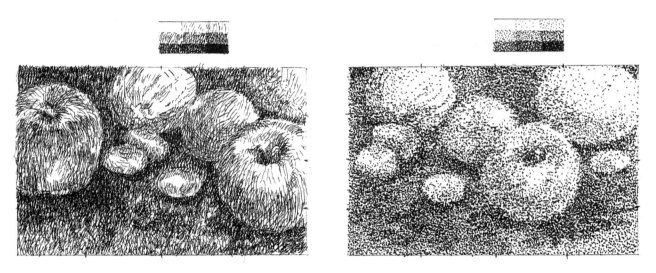

STEP EIGHT

would it be wise to reveal them together in order to assess and evaluate your progress.

Try drawing two different views of the same still-life group. Simply shift your viewfinder from side to side or move it nearer to you or further from you. Do not change the arrangement of the still-life group. Very soon you may like to draw panoramic views, sea-scapes and woodland scenes and you will find it impossible to change the scenes by demolishing mountains and digging up forests! Therefore, practise the habit of using the viewfinder to help you select *various* views of the *same* scene.

Try using different pencils for each drawing and try employing a different technique for each pencil. You could follow my example by trying a curved cross-hatch technique for one and a juxta-position of dots for the other. Alternatively, you could explore other ways of using the pencil, such as a straight cross-hatch on its tip for one and a soft rounded movement on the side of the pencil for the other.

If you examine carefully the two sequences of steps in the previous chapter (pages 41–6) you will see how the gradation of tonal values is achieved by two main processes. One is how distant or close is the placing of the marks, and the other is how little or how much pressure has been exerted on the pencil. You will also see from the sequence of steps illustrated on these pages (49–51) that the gradation of tonal values is achieved by the first process only.

Try such variations yourself. Refer to your 'tones without tears' experimental sheets and remember that one way is neither 'better' nor 'worse' than another, any more than one way is necessarily 'easier' or 'more difficult' than another except in our own judgement. Treat all ways, methods and techniques as equally valuable systems of exploring the various adventures in this voyage of discovery and the various stages of our games of serious fun.

Soon you will discover a number of very useful advantages concerning the necessity of appropriate speed, the transference of knowledge and the enormous psychological relief of the 'safety-net' generated by contriving concurrent activities. These and a number of other helpful devices arise out of rules four, five and six. Practise making two concurrent drawings before reading on.

Rule seven – Be positive in criticism

Let us be clear about one thing, there is nothing wrong with criticism. The emphasis, however, is on the kind of positive criticism which we discussed in Chapter Two when we were exploring the nature of our drawing materials by means of our sensitivity sheets. You will remember that, in order to observe what occurs clearly and objectively, we need to do so in an almost dispassionate manner. Curiously enough, although this may sound careless and uncaring, it is quite the reverse! In order to take care of our development as people who want to draw, we need to put into practice proper assessment and evaluation in a careful and caring manner.

This rule is probably the most difficult to apply because many of us are conditioned to self-deprecation. It is all too easy to rubbish our own efforts and despair of ever improving.

There is nothing either good or bad,
but only thinking makes it so.

WILLIAM SHAKESPEARE

Fortunately, Hamlet's wise words make us realise the futility of criticism based on either simplistic preferences or prejudice and bigotry. Let us ignore such negative practices. Let us be positive in our criticisms by acknowledging mistakes clearly and objectively so that necessary corrections may be applied. For example, let us say if some lines are too dark 'They are too dark and therefore we may make them pale with the putty rubber.' If something is too large or too small, or too high up or too low down, or too much to the right or too much to the left, let us say so with a happy acknowledgement that alteration can immediately be made. Whatever is noticed in this way can be confirmed, if it should seem appropriate, and whatever is inappropriate can easily and quite happily be rectified.

In this way we can develop our skills in assessing clearly what has been done and evaluating this not only for future purposes but also for present enjoyment.

Not only will everything be all right,
but everything is all right.

HUBERT S. BOX

Now try putting such positive criticism into practice about your last two drawings. Do so after you have had a rest from doing them by engaging in another activity altogether. In this way you will discover that your assessment will be clearer and your evaluation will enable you to see the true value in what you have done, not only for your future development but, as I said earlier, for your present enjoyment – amazement even – now!

Nothing is there to come,
and nothing is past,
But an eternal Now
Does always last.

ABRAHAM COWLEY

There will be many occasions when we need to praise ourselves! You will already have noticed how I will keep urging you to congratulate yourself in your endeavours throughout this book. Do so now by spreading out all your drawings before you and acknowledging your progress.

More monochrome drawing

All the principles of perception, techniques of drawing and practices of shading you applied to your still-life studies can equally well be applied to a subject, indeed to any subject.

HANDKERCHIEFS

Let us try something so 'anonymous' that it could be almost anything: crumpled white handkerchiefs (see below). A viewfinder has been placed such that part of the subject is isolated. Except for a little stitching there are almost no references to help us recognise or 'name' the subject with our left hemisphere. Like an extreme close-up photograph, this small detail of the handkerchiefs, it seems, can be understood only by our right hemisphere. And herein lies its advantage: it compels us to look very carefully, because there are virtually no preconceptions about it forthcoming to our left hemisphere.

Although the idea of a subject with such general implications as this crumpled linen is acceptable in theory, it presents a rather terrifying challenge because of its apparent complexity.

CRUMPLED HANDKERCHIEFS

Thus I have deferred such a dangerous game until now, when I believe that you are ready for such a spur as this to promote your development.

Danger, the spur of all great minds.

GEORGE CHAPMAN

As always, make yourself relaxed and attentive by practising the Golden Cord exercise. Clip a fresh sheet of A3-sized white cartridge paper on to your drawing board, sharpen some soft pencils such as a 2B and a 4B, and have a ruler and putty rubber nearby. Draw two empty rectangles side by side on the top of the paper (see Step one for guidance). They do not have to be the same size or proportion as each other. However, they do need to be the same proportion as the viewfinder or viewfinders that you choose to use.

The way you arrange your handkerchiefs is important. Make a slope on your table by resting a flat object like a large, thin book on a pile of smaller books. The slope should not be more than 30°. On this slope place a sheet of white paper and on the paper lay flat a white handkerchief. On this flat handkerchief arrange another white handkerchief in a multiple of folds and creases. When you view this arrangement through your viewfinder, you should see only either part of the crumpled handkerchief or part of the crumpled handkerchief plus some of the flat handkerchief. In Step one, a part of both handkerchiefs is

visible. Such care is necessary because your arrangement contains virtually no variation in colour; the main differences and variations will be in tonal values only. In *this* respect the subject is less complex than the still-life arrangements which we drew earlier, which held many variations of tone *and* colour. In order to perceive the full range of tonal values more easily, try placing a table lamp on one side of your arrangement. This will show a wider range between the very pale and the very dark tones.

Steps one to five show that the procedure of developing the drawing is exactly the same as those we have already practised. Follow the same system of shading from light to dark, but choose one particular technique or a variety in the way you use the pencil. (In the illustrations, both drawings were developed by using a very soft pencil on its side and moving it very gently at angles inclined more towards the vertical.) Remember to enjoy the whole process of drawing through the operation of the senses. Not only is the sense of sight important, but so also are those of touch and hearing. Feel the vibrations and listen to the sounds of the pencil as it travels over the surface of the paper as well as enjoying the sight of the marks as they occur. Employ all of your perceptual responses to the full.

When you have finished one or two attempts at this game, spread out your results before you. Remember rule seven: 'Be positive in criticism'. Engage in the necessary virtues of assessment and evaluation which we discussed and explored

STEP ONE

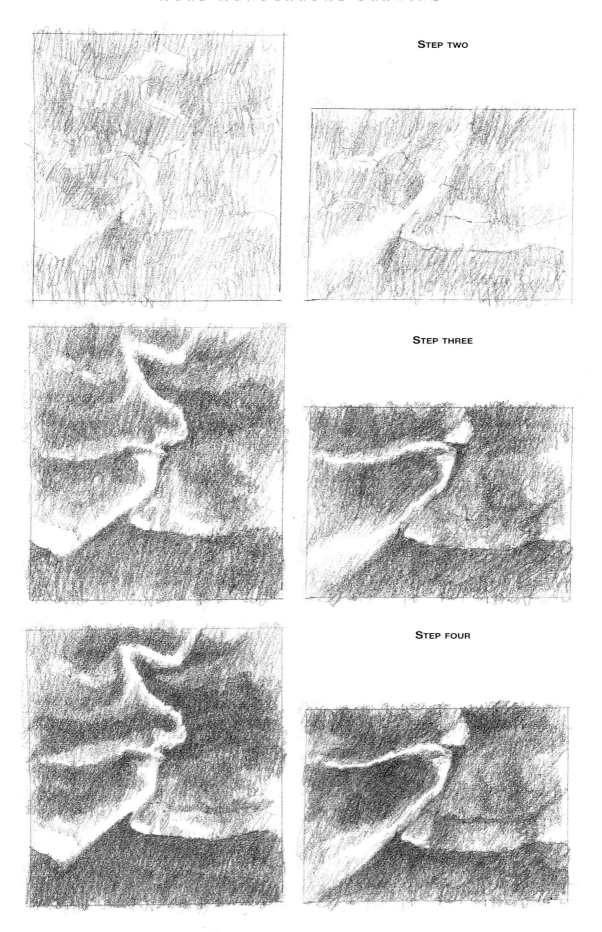

STEP TWO

STEP THREE

STEP FOUR

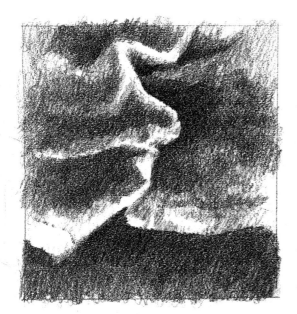

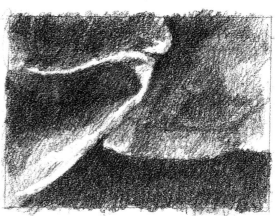

STEP FIVE

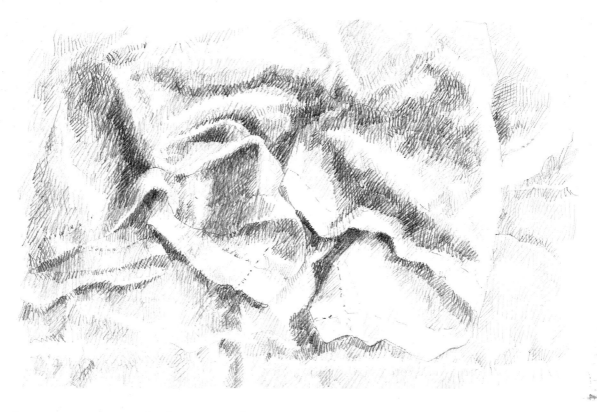

together on page 52. Now look again at all your drawings and also the illustrations on pages 54–6. Become aware of the anonymity, the generality and even the universality of the subject you are portraying. *You* know you have drawn handkerchiefs, but what else could the images which you have created be? Clouds; patterns in tree bark; rock formations; landscapes? Let your imagination lead you.

A COMPLETED DRAWING OF A LARGER VIEW OF THE HANDKERCHIEFS

The identical system of shading from light to dark has been employed. However, a hard H pencil and an even harder 2H pencil have been used on their tips so that a fine cross-hatched technique creates the range of tonal values and depicts the illusion of folds and dells in the creases of the material. Try this or other techniques for yourself. Refer to your previous tonal experiment sheets to help you choose.

CLOUDS

Clouds are another subject that you may once have thought 'difficult' before you realised that 'difficulty' resides in the mind and not in the subject! Clouds, especially at sunrise and sunset, have inspired many an artist to create new inventions in drawing, and even in other areas of knowledge, because of the originality with which they change in shape, texture and colour.

I have seen shapes in clouds and on patchy walls which have roused me to beautiful inventions of various things and even though such shapes totally lack finish in any single part they were not devoid of perfection in their gestures or other movements.

LEONARDO DA VINCI

Although no subject in itself is 'difficult', some are certainly more *complex* than others. Therefore, as always, we need to treat ourselves gently. Let us start by drawing another artist's drawing, or even copying a photograph. You will remember that on page 26 we discussed the value of copying which, although sometimes maligned, helps us to see the world through someone else's eyes. So long as we combine such practices with our own drawings from life, it will help us to enlarge our experience, our knowledge and our eventual wisdom.

Choose, then, for your first attempt, any photograph or artist's impression of clouds. You could even choose the completed example *Clouds at Sunset* (below). Follow the same shading procedure from light to dark as we have practised before, and select any technique you wish.

For your second attempt try drawing clouds from life. You have nothing to fear or be uneasy about because all these experiences are part of the adventures in this your voyage of discovery. You will need to prepare your equipment beforehand, even by a few days. Set it up near a window so that you can see the sky from an expansive vantage point. If you are prepared thus in advance you can attend immediately to drawing the everchanging shapes and tones which form the fleetingly scudding clouds as soon as they appear.

There are five possible procedures (listed overleaf) to employ which will help us in our approach to depict subjects, like this, that change their forms and their tonal values in this way.

CLOUDS AT SUNSET

'THUMBNAIL' SKETCHES OF CLOUDS

1 Return every day at about the same time for a short period, say ten or fifteen minutes. This is especially helpful when the form is static or if it is known that similarly shifting forms are to be present on a daily basis.

2 Draw the main contours very quickly, but also very carefully, throughout the entirety of the desired composition. This need not be very expansive; the viewfinder, held for a couple of minutes, will help the selection of a small detail. With equal speed, indicate the position of the very pale tones by leaving them as the white of the paper while shading the rest of the composition very lightly. If this is done with the utmost attention, many of the positions and values of the other tones will be remembered. You can ally the next procedure to this one, too.

3 Use the newly changing formation of shapes and tonal values to assist the development of the initial statement of what was first seen. Although forms will change position and tonal values will likewise change places, it is possible to re-apply a particular arrangement of forms or to transfer certain tonal values from a present position to the original configuration of the initial statement. And herein lies a fourth procedure which may also be included.

4 Because the process of working from pale to dark tones allows for immediate and simple corrections and change, it is perfectly possible to alter the initial statement here and there so that the composition grows and changes, just as the view of this particular subject of clouds grows and changes.

5 Make what are described as 'thumbnail sketches', sometimes called 'vignettes'. Both refer to the making of small rapid sketches of subjects. This is a particularly useful exercise with the transitory nature of such constantly moving subjects. If a number are drawn (see *'Thumbnail' sketches of clouds*, above) it is possible to synthesise a whole picture from such components subsequently.

When I draw or paint a subject from life which is transitory, organic or in some way mobile and dynamic, I employ various combinations from all five procedures. Occasionally I even include the use of photographs, as I have suggested you do too. However, their use is 'as well as', never 'instead of', drawing directly from the subject.

Try these procedures yourself and see how well you manage them. After a number of attempts, you will discover there really is nothing like the challenge of a real-life subject. In a way, the more it changes, the more elusively it behaves, the more attractive it becomes. It is almost like falling in love!

ROCK FORMATIONS

Let us change the subject to one which is more static as a rest from the mobility of clouds. But let us choose again one about which we have relatively few preconceived ides, one which will thus require our rapt attention. Stones, boulders and rock formations suit such requirements very well.

On a sheet of black paper or black cloth, arrange a small pile of coal. If you can afford it, use anthracite; because of its shiny surface it will catch and reflect the light beautifully (see my illustration below).

Set up your viewfinder to select a part of your arrangement just as you have done before. Prepare in a restful and easy manner so that you may enjoy the activity to the full.

Draw using a mixture of hard and soft pencils and with as few rests as possible. Drawing continuously helps the unity of all parts of a composition to become immediately apparent. Do not worry if your initial outlines become blurred; you will remember that on page 42 we discussed how losing some of the initial outlines can facilitate necessary alterations when practising the method of shading gradually from light to dark.

The more you study this 'black-on-black' subject, the more you will realise that distinctions between 'known' contours such as the lower edges of a piece of coal and the start of a cast shadow on the black paper are almost impossible to detect because of their nearness in tone.

When you have finished a few drawings of this subject, assess and evaluate, and once again engage in a kind of reverie. Do your drawings suggest rocky landscapes to you? Why not now draw such a landscape? Start by seeking out a photograph of such a subject and copying it. Then try something similar from life. You do not necessarily have to make a special trip to the countryside, if you live in an urban area: you may have a rockery in your garden or a similar scene may be provided for you at your local park. On page 60 is a drawing of a spot called Hallins Fell at Ullswater, which I visited a few years ago.

I am sure that you will enjoy your first experience of drawing in the open air. The natural outdoor sights and sounds, be they from garden, park or the great outdoors, all help to enrich the total experience and your recording of it.

ANTHRACITE

Above:
Copy of a photograph of rock formations on the summit of Glyder Fach (photograph by Michael Leach. *Secret Life of Snowdonia* Chatto and Windus Ltd).

HALLINS FELL, ULLSWATER

FOLIAGE AND TREES

Now that you have had your first taste of being in the open air you will quickly develop an appetite to continue drawing out of doors. Take every opportunity you can to do so. Do not be embarrassed by onlookers. Instead, put yourself in their position: they are likely to be much impressed by the fact that you are brave enough to be drawing *at all,* let alone in public. Remember too that you are drawing to please yourself and no one else.

Sometimes the inclement weather prevents our venturing outside. On such occasions bring your subjects indoors. For example, below is a drawing of ivy leaves which I trailed over some birch logs and arranged on the table in my studio.

The patterns of trees as silhouettes against a rising or setting sun affords a fascinating study. *Sunrise through Trees* (page 62) recalls the similarly majestic light which I explored in my study of clouds on page 57.

Whenever you practise drawing outdoors, take your equipment, a folding stool and a light col-lapsible easel and settle yourself comfortably for a few hours so that you can explore the scene before you to your heart's content. Your viewfinder, as always, will help you select a part of the whole vista which pleases you.

Although the range of different 'named' features may seem daunting – for example the trunks, branches, twigs, leaves, foreground and background in a woodland scene – do not let this deter you. Remember that we are really seeing the play of coloured light and shadow in their various positions and proportions, and it is *only* this which we see. Rest in this knowledge and you will discover that your hand will draw the scene before you and integrate all the individual features into a unified whole.

IVY LEAVES AND BIRCH BARK

I chose the logs simply as a support and a foil to the leaves yet as I began to draw I became equally attracted to the patterns in the curling bark of the birch. However, it was important not to over-emphasise these patterns as they would have detracted from those in the leaves.

SUNRISE THROUGH TREES

St Enodoc Church, North Cornwall
by Sally Blenkinsop

*The artist must look directly at nature and not follow
the style and formulae of others, Otherwise he would be
the grandchild and not the child of nature.*

LEONARDO DA VINCI

Beeches at Burnham

Note the play of light on the gnarled trunks, twisting branches and
the heavy canopy of leaves of these beech trees at Burnham. There
are two phenomena manifested in the drawing which help to create
the illusion of depth in space. One is the seemingly smaller size of
objects as they recede into the distance. The trees appear to be in
the background because of their smaller size. The other
phenomenon is how, in certain climatic conditions, objects in the
distance seem neither very dark nor very pale; they appear to be
formed by mid-tones only. Those in the foreground exhibit a much
broader tonal range, from very dark to very pale. Such phenomena
are helpful to us when they occur and can be utilised accordingly.

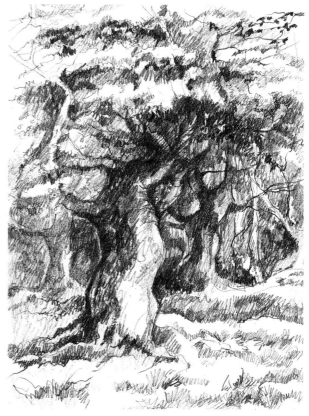

FLOWERS

I love to draw flowers! There is something very special about their form, colour and fragility.

―――――――

Flowers are the beautiful hieroglyphics of Nature, by which she indicates how much she loves us.

JOHANN WOLFGANG VON GOETHE

―――――――

Springtime is particularly beloved by all artists. The sweetness and fragrance of blossoming trees and flowering shrubs everywhere fill the senses. It is a time when all is burgeoning in such profusion that we are almost spoilt for choice. Take your chair, easel and drawing equipment to a favoured place in your garden or the local park and find some flowers to draw. Enjoy all of Nature's perfumes and sounds as well as her magnificent sights manifested in the delicate tones of these fragile spring offerings.

Let us start with the primrose, which Robert Burns described as 'This firstling of the Infant Year'.

For this project we will try a new technique with different drawing materials additional to those we have used before. Steps one to six show the development of a study drawn with pen and ink. To try a pen-and-ink drawing you will need an ordinary 'dip pen' with a relief nib, a bottle of waterproof ink and a small jar of water. Dilute a drop of ink in a small puddle of water and mix this pale fluid on an old saucer or plate. Fill the nib and start to draw on cartridge paper the main contours of your composition, as in Step one. Develop the drawing tonally from pale to dark using the cross-hatched technique with which you should now have become quite familiar. At each stage you will need to add a little more ink to the puddle in your saucer so that your drawing becomes gradually darker by the progressively darkening ink and also by the increasing density of your cross-hatched lines.

When you have finished this study with pen and ink, try the same subject using familiar drawing materials and techniques (see the study of primroses below). Notice how what you learned from the pen-and-ink study informs this drawing.

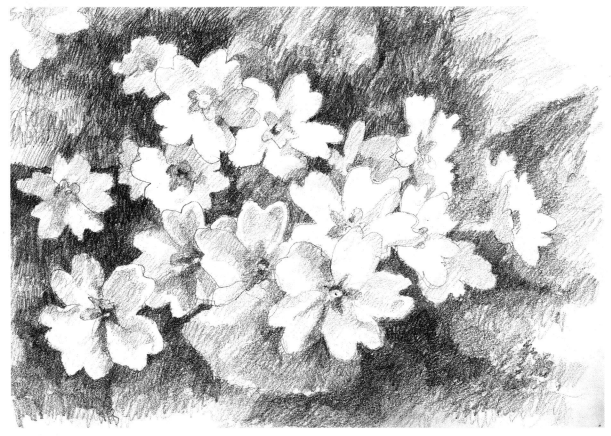

STUDY OF PRIMROSES IN PENCIL

STEP ONE

STEP FOUR

STEP TWO

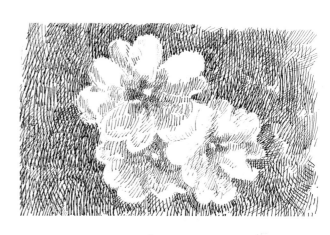

STEP FIVE

STEP THREE

STEP SIX

It never ceases to amaze me how seemingly un-related materials and techniques appear to inform each other about the principles of their uses.

Every month of the year offers new flowers to draw. Even in December and January there are hellebores and winter jasmine, although of course summertime excursions are usually more pleasant and rewarding.

Until now we have dealt with inanimate, though not necessarily unmoving, objects. It is now time to tackle what, for many, seem the most daunting subjects of all – animals and people.

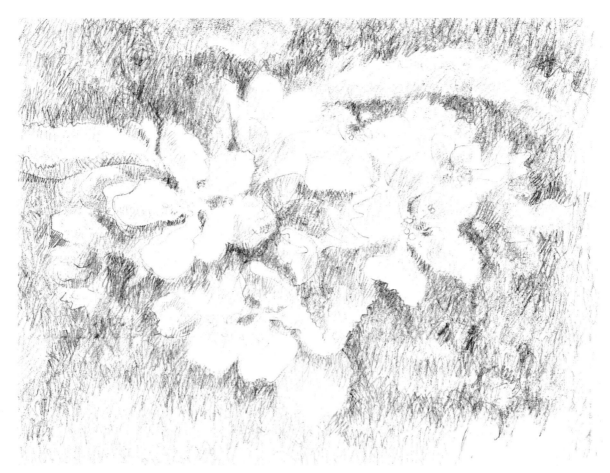

Above and below: **CRAB-APPLE BLOSSOM**
These two studies were drawn concurrently.

Above:

DAISIES

Right: A single 'Iceberg' rose from a bush in my garden. The beautifully complex array of subtle tones displaying themselves over its folding petals is reminiscent of the same array that we investigated and discussed in the crumpled handkerchief at the start of this chapter.

Left above: Detail drawn with soft pencils ranging from B to 4B, used mainly on the tip of the pencil leads to make a variety of cross-hatched marks on to cartridge paper.

Left below: Another detail of the same subject but illustrating a different technique where a 9B pencil was used on the side of its lead, in conjunction with a wax crayon on a heavyweight watercolour paper. Both techniques allow for the white of the paper to manifest itself to a certain degree throughout the whole process of drawing even in the later, darkest areas, either through the process itself (left) or owing to the humps and hollows of the paper.
Both methods bring out the same quality in the subject: the vibrating light inherent in the fragile blossoms and their surrounding leaves.

STUDY OF AN 'ICEBERG' ROSE IN PENCIL

ANIMALS AND PEOPLE

In this final section I include some examples of creatures both great and small, animal and human. Although we all once might have thought of such subjects as 'difficult', the foregoing pages should have laid such negative and damaging thoughts to rest. Indeed, you have already learned the main procedures and processes by which you may approach these subjects. Let us now apply such general knowledge to some particular creatures by way of recapitulation.

Below I have drawn some thumbnail sketches of cats. We discussed the procedure of such sketches relating to moving inanimate subjects in the section on cloud formations earlier in this chapter. It is worth developing this discussion now to include moving animate subjects. The following example applies to any hypothetical pet cat, but the same procedure can be used on any moving subject, indoors or out. (You might find it helpful to re-read the section on making thumbnail sketches on page 58 before you begin.) Start drawing the main contours of your cat and a little background detail. If and when it moves, start another drawing on the same page. After two minutes you may have started as many as ten thumbnail sketches of the animal in various positions all over the page. As soon as your cat takes up any of the same positions again, return to the relevant drawing and develop it and the surrounding area. It is just as important to attend to the setting as it is to the subject. Shapes and tonal values in both subject and background are more easily understood when they are seen and drawn together as a whole.

In this way not only will you probably come to understand the nature of your cat more comprehensively, but you will also have embarked on a new phase of your artistic development: you have just started your sketchbook! Take it with you everywhere and at any spare moment take it out and start drawing. In this way you will keep the discipline of drawing well exercised. The sketchbook can be embellished with magazine cuttings, old photographs, poems, pithy sayings, pressed flowers or leaves, in fact, anything that takes your interest, in addition to your thumbnail sketches for future developments.

The studies of a duck (page 70) and a sheep (page 71) were developed from the thumbnail sketches shown beneath them.

Museums often exhibit stuffed animals and birds, and although these have the obvious

'THUMBNAIL' SKETCHES OF CATS

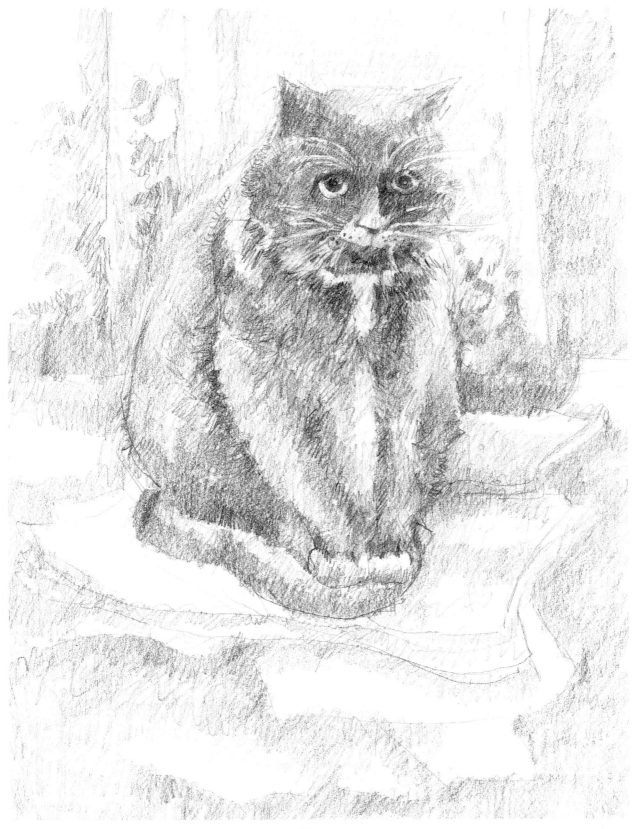

My cat

This was drawn from life from start to finish over a number of days, since my queenly pet only deigns to grant me a brief
audience every morning!

STUDY OF A DUCK

'THUMBNAIL' SKETCHES OF DUCKS

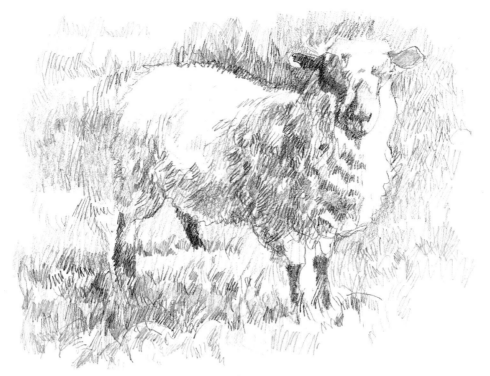

STUDY OF A SHEEP

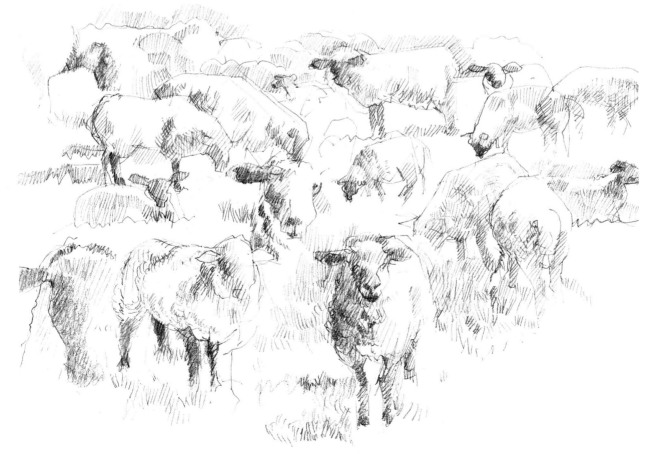

'THUMBNAIL' SKETCHES OF SHEEP

A STUDY OF DAVID

by Michelangelo (original: Accademia, Florence;
plaster cast – Victoria and Albert Museum, London)

advantage of remaining still, they lack the spontaneity of a live subject. More exotic live fauna may be found at a zoo.

Now we turn to the human figure. Of course, you can already draw faces upside down! However, even at this advanced stage, we still need to treat ourselves gently, so I suggest that you choose initially subjects that you know will remain still. Your local museum, church or park is likely to contain some statuary or portraiture that you can practise with until you feel ready to try drawing the human figure from life.

Begin by drawing your friends and neighbours. Then be brave enough to draw people in the streets, parks and public places. Why not join a life-drawing class? To sit in front of a real-life model in the company of like-minded people who are all seeking to explore and express their discoveries about the human form is a very rewarding experience. You will be surprised not only at how many drawings you will produce just by attending a two-hour session once a week, but also at how quickly your competence develops. I find the discipline absolutely enthralling.

RECLINING NUDE

CHAPTER EIGHT

Colour exploration

At last you are going to play with colour. Prepare yourself by practising the Golden Cord exercise, and with quiet attention clip several sheets of white cartridge paper to your drawing board. Supply yourself with a ruler and a pair of compasses and sharpen the six coloured pencils detailed on page 10.

For many of us, colour is one of the most alluring and attractive qualities which Nature has to offer. It will help us to enjoy it even more if we investigate and discover some of its characteristics, and in so doing appreciate more fully its wonderful complexities.

In nature we find all kinds of colour combinations. All colours are components of one source: white light, and this common root allows colours to harmonise with each other in seemingly endless permutations.

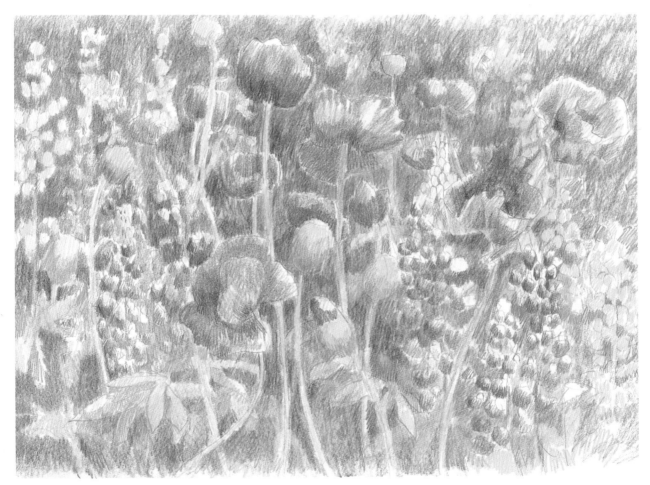

POPPIES AND LUPINS IN THE FLOWER BED

THE COLOURS OF 'OUR' SIX COLOURED PENCILS

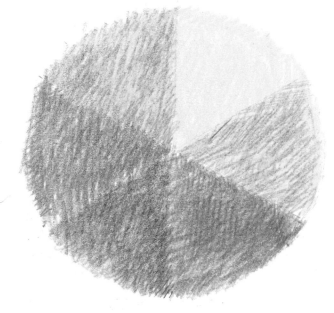

A

The colour circle with six sectors made with the orange-yellow (gamboge), the purple-blue (ultramarine) and the purple-red (crimson) coloured pencils.

Everything comes from everything and everything is made from everything and everything can be turned into everything else; because that which exists in the elements is composed of those elements.

LEONARDO DA VINCI

Incredibly, the average person can distinguish between 120 and 200 individual colours. Maybe this explains the variety of opinions there have been, and still are, about how many 'particular', 'main' or 'distinct' colours there are in the spectrum. Twelve, nine, seven and six have all been proposed by various theorists. For our needs and for the purposes of this book we shall concentrate on just six distinct colours. The first three are *red*, *yellow* and *blue*, which are often referred to as *primary colours*. From mixing pairs of these it is possible to make those colours which are often referred to as *secondary colours*: *orange* is made with red and yellow, *green* is made with yellow and blue, and *purple* is made with blue and red.

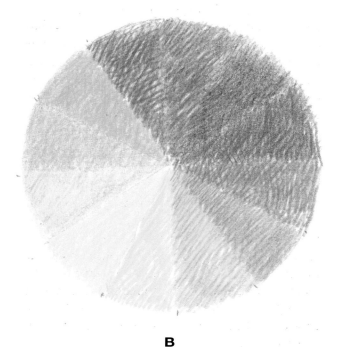

B

B: Colour circle with twelve sectors.
There are two hues of each of the primary and secondary colours. Make a similar circle using all six of your coloured pencils. Note carefully how the hues seem to progress naturally from one to another rather as they do in the rainbow. Six of the sectors are made using a single pencil, and six using two pencils as illustrated. Note that the six secondary hues use only pairs of colours, the difference being achieved by varying the proportions in which the two colours are used; for example, both the green sectors are made with the green-blue (turquoise) and the green-yellow (lemon yellow) in differing proportions.

COLOUR CIRCLES

Circle A (left) illustrates a colour circle with six sectors, each of which contains just one of these six colours. Make your own colour circle using just the orange-yellow (gamboge), the purple-blue (ultramarine) and the purple-red (crimson) pencils to make the *primary colours,* and each one with another for the *secondary colours.* These particular hues are those which were used in colour circle A. Make your colour circle before reading on.

HUE

The word 'hue' is often used to describe the quality that distinguishes one colour from another. Scarlet, for example, is distinguished from crimson by the differing qualities of the two colours: scarlet is an orange hue of red, and crimson is a purple hue of red. Throughout the rest of this book I shall use the word 'hue' with this meaning. Once you have practised the making of the twelve-part colour circle B (left) a few times you will realise that the principle which governs it is really very simple.

TONE

Whereas the word 'hue' refers to the 'colour' of colour, the words 'tone' or 'value', or the term

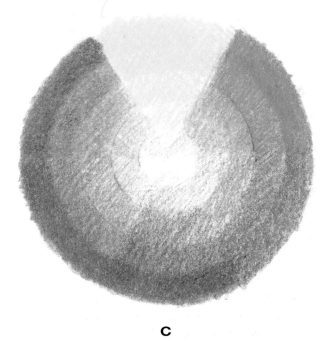

C

'tonal value', all refer to the range (of any colour) between light and dark. We have already explored this particular quality of colour very thoroughly. Look now at the two colour circles again and you will see quite clearly that the palest-toned colour in both is yellow, that the darkest-toned colour is purple, and that in the twelve-part colour circle it is the blue hue of purple.

It is possible, with our coloured pencils, to extend the range of tones of all hues of all colours a certain amount.

Circle C (below left) shows a six-part colour circle where each colour becomes progressively paler towards the centre. Try making a similar circle yourself and notice that the tonal range of yellows is far less extensive than the purples. This will always be so, if only those hues of coloured pencils which are intrinsic to every one particular colour in the colour circles are used. Later in this chapter we will explore how to extend the tonal range of any particular colour by including other colours which are not intrinsic to it. First, however, we need to define a few more terms.

CHROMATIC VALUE

'Chromatic value', sometimes referred to as 'purity', 'intensity' or 'saturation', describes the range between 'bright' and 'dull' (this is *not* the same as 'light' and 'dark'!). Notice how the two hues of green in the twelve-part colour circle B are bright, while the green sector in the six-part colour circle is dull. This is because the green hue of blue (turquoise) and the green hue of yellow (lemon yellow) are intrinsically 'nearer' green than the orange-yellow/purple-blue combination used in the six-part circle A. Thus the green sectors in the twelve-part circle are brighter because there is a vestige of red in both gamboge and ultramarine which makes the green sector dull. Check this yourself; look carefully at these two coloured pencils and notice how a vestige of red is required in the purple-blue in order to make the ultramarine hue, and how a vestige of red is required in the orange-yellow in order to make the gamboge hue. This holds true whatever the tonal value. Even the palest green tone in colour circle A is still 'dull' when it is compared to the dark tone of the blue hue of green in the twelve-part colour circle.

EVALUATING COLOUR

To recapitulate: 'hue' refers to the quality of colour, 'tone' refers to the range between light and dark, and 'chromatic value' refers to the range between bright and dull. We need to understand that all qualities are intrinsic to all colours. Look around the room where you are sitting and select items which are obviously blue, green, yellow, orange, red and purple. Then look at each item in turn and identify the character of these three main qualities of its colour. For example, if you have chosen a red item, what particular hue of red is it: more orange or more purple? What tonal value is it: pale, mid-tone or dark? And what is its chromatic value: bright, not very bright, or dull? Treat this exercise as a game and play it frequently. In this way you will begin to clarify your understanding of colour even more.

GREEN HUES, TONES AND CHROMATIC VALUES

Here is another game which will help to develop our understanding of colour and its characteristics. The illustrations A and B below show the 'tones without tears' exercise (pages 34 and 35) expressed with two hues of green. Try this yourself and you will find that it will help to clarify your understanding of the distinction between the range of tones, and the differences of hues. Try this with two hues of two other colours.

Opposite are thirty-six different greens. (The coloured numbers below each square refer to the number of layers present of that particular colour in each square.) Just four pencils, our two yellows and our two blues, were used to make *all* thirty-six. Try this exercise for yourself. Needless to say, there are many further permutations possible using just these four pencils. Try making equally as many hues of the other colours in the spectrum by following a similar procedure. You will be amazed at the variety and complexity which arises from such simple means. The more you play with colour, the more you will develop your understanding, and the more enjoyable drawing in colour will become.

COMPLEMENTARY COLOURS

Thus far we have discussed the individual qualities and characteristics of colour. Now we shall explore how colours behave when they are related to each other, as they are all the time in the world around us.

'Complementary colours' are those opposite each other in the colour circle. Green is complementary to red, orange is complementary to blue, purple is complementary to yellow. If we look again at the twelve-part colour circle B on page 74,

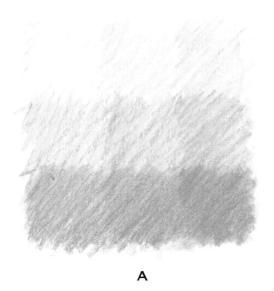

A

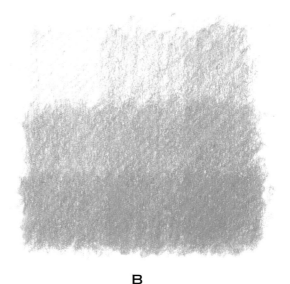

B

'TONES WITHOUT TEARS'

– 'tones in tiers' with two hues of green.

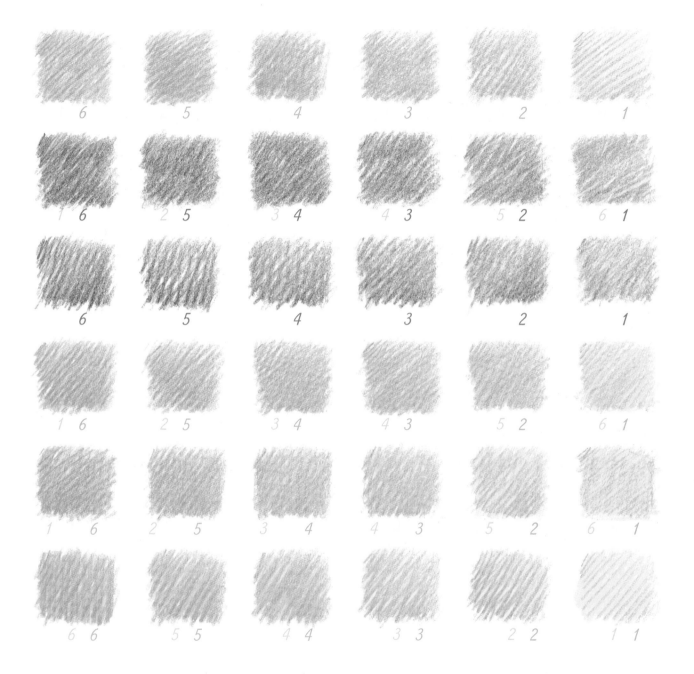

THIRTY-SIX DIFFERENT GREENS

The coloured numbers below each square refer to the number of
layers present of that particular colour in each square. Just four
pencils, our two yellows and our two blues, were used to make
all thirty-six of these greens.

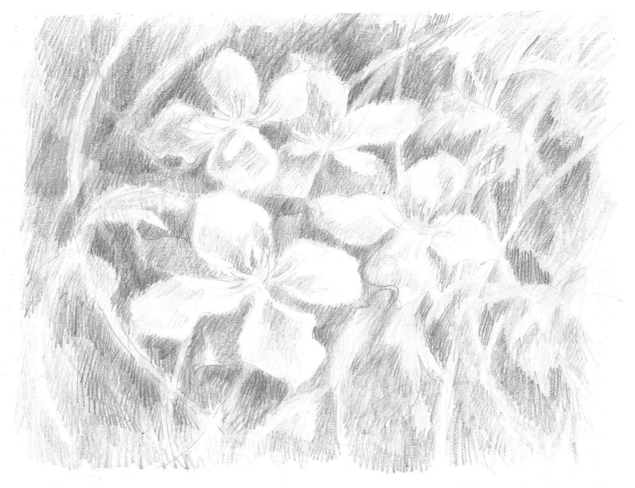

CLEMATIS MONTANA 'ALBA'

we can be more specific: a red hue of orange is complementary to a green hue of blue, for example, and a purple hue of red is complementary to a yellow hue of green.

SUCCESSIVE CONTRAST

Occasionally, complementary colours appear 'before our very eyes', either successively or simultaneously. If you close your eyes after looking at a bright orange image like the setting sun, a greenish-blue circle suddenly appears. It is almost as if our body has given us some medicine in the form of an antidote (the complementary colour) in order to recover from an overdose! (Actually, this is not too far from the truth, although it would take a neurological expert to explain it properly.) This phenomenon is known as 'successive contrast', and it occurs in our perceptual systems.

SIMULTANEOUS CONTRAST

'Simultaneous contrast' is when a pair of complementary colours is perceived at the same time. It happened to me when I was drawing the 'white' *Clematis montana* with my coloured pencils (see above). First of all it was a surprise to discover that the flowers were not really white, but a very pale yellow. It was also even more of a surprise to observe that the petals which were in shadow were not the expected grey but were appearing purple instead! The following passage is from a book called *Theory of Colours* which Goethe wrote nearly two hundred years ago:

During the day, owing to the yellowish hue of the snow, shadows tending to violet had already been observable; these might now (at approaching sunset) be pronounced to be decidedly blue, as the illumined parts exhibited a yellow deepening to

78

orange... But as the sun at last was about to set, and its rays, greatly mitigated by the thick vapours, began to diffuse a most beautiful red colour over the whole scene around me, the shadow colour changed to a green, in lightness to be compared to a sea-green, in beauty to the green of the emerald. The appearance became more and more vivid: one might have imagined oneself in a fairy world, for every object had clothed itself in the two vivid and so beautifully harmonising colours, till at last, as the sun went down, the magnificent spectacle was lost in a grey twilight, and by degrees in a clear moon-and-starlight night.

JOHANN WOLFGANG VON GOETHE

We can experience right now this phenomenon called 'simultaneous contrast', and some other strangely curious but equally wonderful phenomena, by looking at Diagram A below. All three small inner orange-red circles were made with the same coloured pencil and are of the same hue, tonal value and chromatic value. However, they do not appear so; we perceive them as being different from each other. Now compare the small inner circle which is surrounded by the purple-red with that which is surrounded by orange. The inner circle surrounded by the red appears more orange and of a paler tone than the one surrounded by orange, which looks 'cooler', bluer and darker. Focus on the little black spot between the two outer (red and orange) circles and you will perceive the differences between the two inner circles becoming more pronounced in terms of both hue and tone. You will also become aware that the inner circle surrounded by red looks brighter than that surrounded by orange. Thus in all three respects of hue, tone and chromatic value, the inner circles take on the complementary quality of their corresponding outer circles.

Let us examine and explain this manifestation, called 'simultaneous contrast', of hue first, then

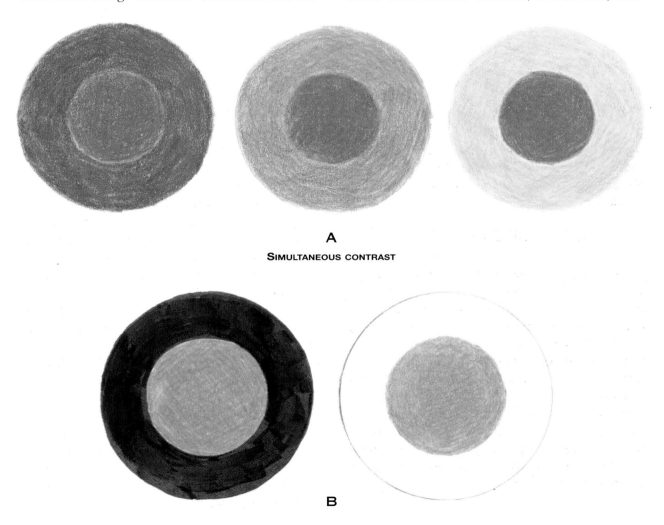

A

SIMULTANEOUS CONTRAST

B

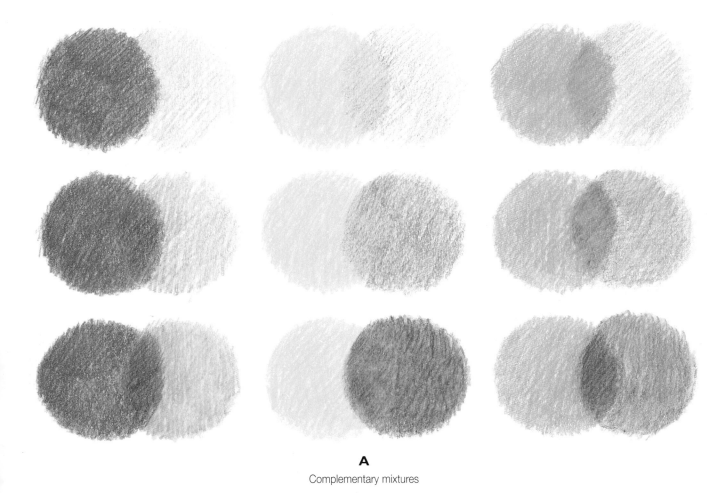

A

Complementary mixtures

tone and finally chromatic value. The contrast of hue is caused by the fact that the purple-red of the outer circle of necessity contains blue. Therefore the inner circle reacts, as it were, to the opposite extreme and appears more orange. Conversely, because the orange of the outer circle is very distinctly orange (neither very red nor very yellow) the inner circle appears 'cooler' and slightly blue. The contrast of tone is caused by the fact that the purple-red of the outer circle is darker than the inner circle. Therefore this inner circle appears paler than the one surrounded by orange. The inner circle surrounded by orange is darker than the surrounding orange, but appears darker than the one surrounded by red. The contrast of chromatic value can be explained by the nature of the coloured pencils used, the purple-red pencil being actually slightly dull and not as bright as the orange-red and the orange-yellow which created the orange outer circle. Thus the two inner circles react in contrasting mode accordingly.

Now compare the two inner circles which are surrounded by red and orange, with the one surrounded by green. Those surrounded by red and orange seem to merge with their surrounding colours. However, the inner circle surrounded by green really does seem pronounced because the red and green complement each other; so much so that each competes with the other rather than merging. Notice also that some of these optical phenomena occur even in Diagram B on page 79, where the two grey circles surrounded by black and white appear different from each other.

The implications of all this for our colour drawing are enormous. With such properties of interaction we can enhance or subdue particular features in our drawings; we can make some dominant and poignant and others subtle and subordinate. I hope you are now fired with enthusiasm to make some similar diagrams of complementary pairs of colours, and some of colours which are 'closer' to each other in the spectrum; then read on.

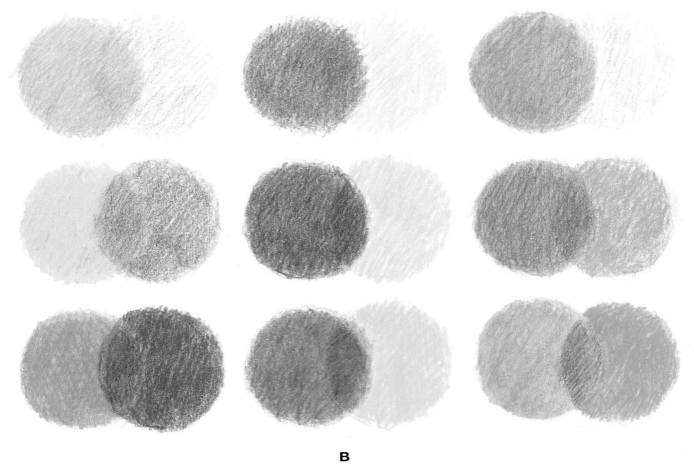

B

Variations of complementary mixtures

COLOUR MIXTURES

We have begun to explore some reactions and interactions among juxtaposed colours. Now let us start to explore what happens when we mix them together and with each other.

The diagram on page 80 (complementary mixtures A) shows three circles of identical reds, yellows and blues placed in vertical format. Circles of their complementary colours, which are, respectively, the secondary colours of green, purple and orange, intersect them. These complementary colours are pale across the top, mid-toned across the centre and dark across the bottom. Look carefully at the top row and notice that where each primary colour is intersected by its pale-toned complementary the colour appears dull. Now look at the middle row and notice that the intersection appears as a dark colour of the primary. Finally, look at the bottom row where the intersections of all complementary pairs appear as

very dark tones of all six colours and also take on the appearance of brown or grey.

Diagram B goes on to show a similar layout using secondary colours placed in a vertical format. However, this time the three columns are not identical. I decided to vary their hues slightly by changing the proportions of the two primaries which composed each column. For example, look at the three greens. The green at the top is a mid-hue of green, the next green is a yellow hue of green, and the green at the bottom is a blue hue of green. The complementary primary colours which intersect them are arranged as were the secondary colours in A. They are pale across the top, mid-tone across the centre and dark across the bottom. Once again, if you look carefully at all the intersections, you will see how a pale tone of a complementary dulls its opposite colour, how a mid-tone of a complementary darkens its opposite colour, and how using equally dark tones of both complementaries darkens both colours to such an

81

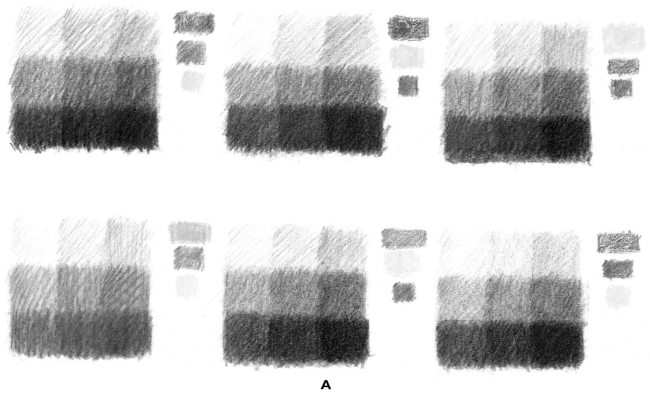

A

TONES AND HUES OF BROWNS, GREYS AND BLACKS USING THREE COLOURED PENCILS FOR EACH EXAMPLE

extent that they appear either brown or grey.

Experiment for yourself, limiting yourself for the time being to one hue of each of the primary coloured pencils in order to 'prove' the rule. Diagrams A and B were made with just the purple-red (crimson), the orange-yellow (gamboge) and the green-blue (turquoise) pencils. Amaze yourself with the variety that can result from even such a limited colour selection.

GREYS, BROWNS AND BLACKS

Now let us explore how we can mix the three primary colours together, quite specifically, in order to make various greys, browns and even blacks. Diagram A above depicts a range of tones of various browns and greys. Some of the darkest tones appear as coloured blacks.

At this point it would be very useful for you to select some black articles from around the house and arrange them together on the table in front of you. As well as perceiving different tones, because of light and shadow, you will also notice how each article appears a different colour. Remember Ruskin's statement about Velasquez: 'There is more colour in his black than most painters have in their palettes'?

The colour 'keys' to the right of each illustration represent not only the hue of whichever primary colour is used, but also the *amount* used. The order in which they are arranged from top to bottom indicates the sequence in which they are used. You will also see that the three illustrations in the top row are all composed with the same hue of each of the primary colours. Although the *sequence* or *order* makes some contribution to the difference of colour that you see in the three illustrations, it is not nearly as significant as the *amount* of each colour used. The top left illustration appears as a range of tones from blue-grey to blue-black; this is achieved by using more blue than red, and slightly more red than yellow. Note also, however, that all three colours must contribute each time as each of the nine sections is developed. If you now look at the illustration at the centre of the top row you will see, again, that all three colours must contribute each time as each of the nine sections is developed, but more red is used than yellow and slightly more yellow used than blue. This particular proportion of the

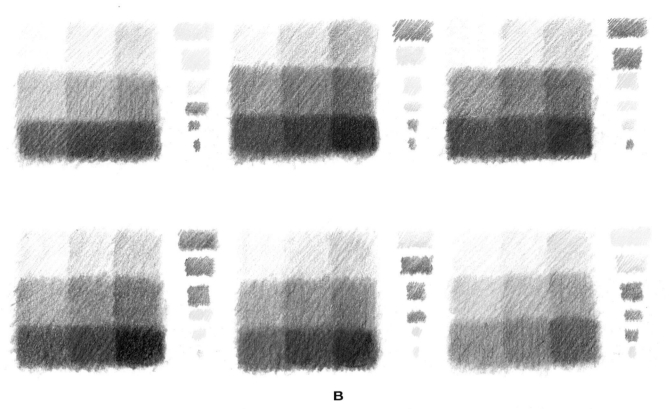

B

VARIATIONS OF TONES AND HUES OF BROWNS, GREYS AND BLACKS USING SIX COLOURED PENCILS FOR EACH EXAMPLE

amount of colour gives the appearance of a range of tones from red-brown to red-black. The illustration at the right in the top row appears as a range of tones from yellow-brown to yellow-black. This time, more yellow has been used than blue, and slightly more blue has been used than red. Once again note that all three colours are used to develop all nine stages of the illustration. In other words, each colour is used nine times for each illustration, and each time slightly more pressure is used to help darken the tone. In total, the number of layers for each illustration amounts to thirty-six!

The bottom row depicts slightly different hues of browns, greys and blacks. Again the colour keys show which primary hues were used, in which order and, most importantly of all, the proportion of their respective amounts.

Try now making such a tonal range of browns, greys and blacks yourself, then read on.

Now that you have made a tonal range of browns, greys and blacks with just *one* particular hue of each of the three primary colours for each attempt, try making some with *two* hues of each of the primary colours, as in Diagram B above,

where all *six* coloured pencils have contributed in various orders and, most importantly, in different amounts. Once again, you are bound to be amazed at the seemingly miraculous powers of just six coloured pencils.

'COLOURED BALLS'

As always, use the Golden Cord exercise before (and during) every activity to purify your mind and free it from tiresomely interfering thoughts.

Diagram A (page 84) depicts six coloured circles which take on the appearance of balls or spheres; they look three-dimensional. The three primary coloured circles are in the top row, and their complementaries (being also the secondary colours) are positioned below them.

A colour key is placed at the right of each coloured ball to show you how it is made.

Look now at diagram B which illustrates just one of these coloured balls, the caption for which explains how you can make one yourself. Once you understand how to make one coloured ball you will be able to follow the underlying rule which is the same for all the others.

All the other ones are constructed in the same way and by the same proportions. Make them yourself, using colour keys on the right of each. The colour or colours at the top of each key refer to the main colour of each ball. Remember to keep the top third pale, but graded, and endeavour to make the bottom two-thirds as dark as the relevant colour pencil (or pencils) will allow. The colour or colours at the bottom of each key always refer to those which contribute to the darkening effect of the shadowed area of the coloured ball. They are all to be used sparingly, and only in the bottom third.

Our finale takes the form of an ensemble in that all we have learned and done comes together

The purest and most thoughtful minds are those which love colour the most.

JOHN RUSKIN

to magnificent effect. Diagram C shows six coloured balls in two hues each of red, yellow and blue. Diagram D shows a similar arrangement in green, purple and orange. From the colour keys you will notice that all six coloured pencils have been used. The key is arranged so that the top colour for each 'primary' ball is, as before, its

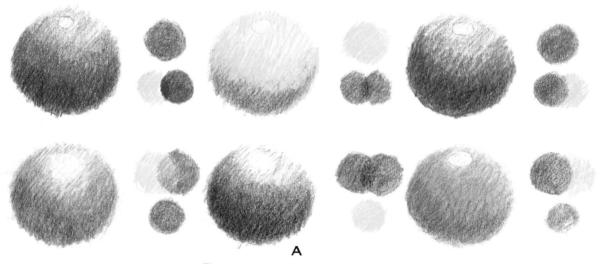

A

The coloured balls (three coloured pencils)

B: THE RED-COLOURED BALL

First of all, draw a circle and colour it all a very pale red. Use the purple-red (crimson) coloured pencil... draw a tiny circle near the top and colour the rest of the coloured ball with another layer of red so that it all becomes a little darker except for the tiny circle, which remains pale and will eventually become the 'highlight'.

Continue to shade the coloured ball so that the top third is progressively and gradually pale to dark and the bottom two-thirds of the coloured ball is very dark red. Look now at the colour key to the right of the coloured ball. The large red circle represents the main colour of this coloured ball, which you have just used; the two smaller intersecting circles of the orange-yellow and purple-blue represent the complementary colour of green which contributes to make the shadowed area of the coloured ball dark. The yellow and blue coloured pencils are used very sparingly and only in the bottom third of the coloured ball; their contribution is only to help darken the red which is already dark by dint of your pressure.

B

The red-coloured ball (three coloured pencils)

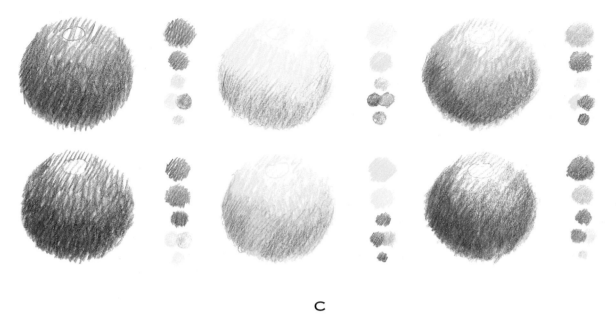

C

The coloured balls: variations of primary colours (six coloured pencils)

main colour. Likewise the top two colours are the main two colours for each 'secondary' coloured ball. Notice how the second colour for each 'secondary' coloured ball is slightly smaller in size than the colour above it, meaning that less of it has been used in achieving that particular hue. (Remember to make the bottom two-thirds of all twelve coloured balls as dark as their particular and relevant coloured pencils will manage of themselves.) Likewise, in descending order and diminishing size are the remaining colours. All contribute to the bottom third and help to achieve the darkening effect of each coloured ball by being used sparingly.

Play now until your heart is content and your mind pure so that, as John Ruskin said, you develop 'The purest and most thoughtful mind', and become one of 'those who love colour most'.

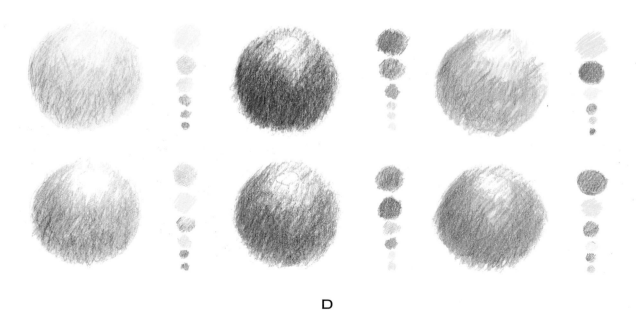

D

The coloured balls: variations of secondary colours (six coloured pencils)

CHAPTER NINE

Simple colour drawing

It is time to bring together all that we have investigated and discovered about colour, its characteristics and qualities, aspects that will now help us to express our responses to the world. We shall begin with a similar still-life subject to that which we drew in Chapter Five, and we will remain with just one drawing of it for the entirety of this chapter. Read and perform each instruction in turn. In this way your understanding of what you do will gently and smoothly accumulate.

PREPARATION

After practising the Golden Cord exercise, arrange some oranges, onions, tomatoes, a lemon and, perhaps, a few grapes on the table. In front of this group, position your viewfinder. As before, allow the viewfinder to select part of the still-life group and *some* of its shadows and reflections on the table (see page 38).

Clip an A4-sized sheet of white cartridge paper to your drawing board, sharpen your six coloured pencils and place these with a ruler and a putty rubber on the table within your reach.

Once again, draw a rectangle on the paper that is the same proportion as the inner rectangle of your viewfinder but not necessarily the same size, remembering to indicate your 'map references', because these will help you to estimate the relative positions and proportions of your compositional features.

Clip also to your drawing board a sheet of paper that shows one of your twelve-part colour circles (see B on page 74), an illustration of the progression of tones from grey or brown to black (see B on page 83), and examples of red-, yellow-, blue-, green-, purple- and orange-coloured balls, each of which has been composed with all six coloured pencils (page 85). This will be an invaluable 'crib sheet' to which you will need to refer from time to time throughout the whole of this forthcoming drawing

process, and a most important guide in this next, most amazing adventure in your voyage of discovery.

We shall return to the analogy of the theatre. Pretend that you are an actor performing in a play. Acting, like drawing, must be taken seriously, but should also be both entertaining and enjoyable. Remember the rules for our games of serious fun discussed in Chapter Six (pages 47–52).

REHEARSALS

Try a few trial runs. You will remember that in Chapter Five you pretended to draw on an imaginary sheet of glass which was suspended on the viewfinder. Perform this kind of 'drawing' again. With one of your coloured pencils in your hand, trace on this imaginary glass all the main contours which you see. Trace them several times, and each time relate them to each other and to the points on the viewfinder. Spend about a minute doing this.

Now enact the 'dress rehearsal'. This time select one of your six coloured pencils which seems to you to be an obviously main contributor to recording your response to the subject; simply choose a colour that appears important in the scene in front of you. 'Draw' a quarter of an inch over the rectangle on the paper the main contours at which you have just looked and are continuing to look. Keep your eyes mainly on the subject and only occasionally glance down to the paper. Allow yourself to be informed by the subject.

ACT 1, SCENE 1

Before we enter on the stage we need to ensure we are wearing the appropriate costume for each scene! Pretend that the coloured pencil which you choose to draw each stage of the drawing is the 'costume' that you wear for each scene; it is the colour in which, and by which, you perform. Take now the same coloured pencil you chose for the

'dress rehearsal' (your last trial run) and write the numbers '1.1' (to represent act 1, scene 1) by the side of your rectangle with *this coloured pencil*. The diagram shows my choice in purple-blue. Recording what you are about to do with the appropriate colours at every stage will be an extremely helpful record for you to refer to as your drawing develops; it will act as a reminder for what you are about to do, and a reference for all that you have done previously.

Now draw on the paper all the main contours of your composition with this coloured pencil. Keep your lines broken and of a very pale tonal value. Look again at the diagram to guide you. Your lines could even be shorter, further apart and paler than those illustrated. Be firm in your conviction and be resolute but gentle in your performance.

Once you have finished, put the pencil down and rest for ten seconds. Then read and enact the next scene.

ACT 1, SCENE 2

Take up another coloured pencil that is a hue of *another* primary colour which you see as being important in the subject before you. Write '1.2' with this coloured pencil, as I have done in the diagram with the orange-red. With *your* chosen coloured pencil, correct or confirm your marks representing the main contours of your subject and which are the main contours of your composition. Rest for ten seconds as before and then read and perform the next scene.

1·1

ACT 1, SCENE 1

(purple-blue)

1·1
1·2

ACT 1, SCENE 2

(orange-red)

1·1
1·2
1·3

Act 1, Scene 3

(orange-yellow)

1·1
1·2
1·3

2·1

Act 2, Scene 1

(green-yellow)

1·1
1·2
1·3

2·1
2·2

Act 2, Scene 2

(orange-red)

ACT 1, SCENE 3

Select one hue of the remaining primary colour which you believe is also important to the scene before you and proceed as before (see 1.2). Correct or confirm your contours which are still pale and broken and thus, even at this stage, should not require removal. (In fact, they are all needed as guides for ensuing marks.) As before, you will remember that several broken lines, taken *together as a whole*, describe and represent the contours which you see in the subject. Above all, remember to keep your eyes on the subject for much of the time. Allow yourself to be continually informed by the vast and subtle variety of directions, sizes and positions of what you are looking at. Avoid assumptions; these lead to stereotypical scrawls! Rapt attention, on the other hand, lends uniqueness and originality to your responses and thence to your drawing. When you have finished, allow yourself a minute's interval before commencing act 2.

ACT 2, SCENE 1

Choose a part of your composition that you wish to colour first. Look at the subject and decide which of your six coloured pencils is the closest hue to that part. Look now at the diagram and you will see a part of the composition near the top left which has been coloured a pale tone of green-yellow. This part represents a lemon. Because I perceived that the green-yellow pencil was the closest *hue* to the lemon, I coloured this part with that pencil. Before I proceeded, I wrote the numbers '2.1', as shown. Perform likewise with your chosen coloured pencil. As you draw, remember to keep your eyes on the subject and allow your hand to move in different directions so that it describes the inner directions and apparent 'movements' of what you see. Allow yourself to *construct* the form and avoid simply 'filling-in'. At this stage colour even the palest areas of your chosen part, because in this exercise no specific white areas are to be left, only the narrow spaces between hatched or cross-hatched lines or hollows in the paper surface are to remain white. Thus even at this early stage we are determining that highlights are to be coloured. Also, at this early stage, keep your pressure on the pencil very light and gentle; the tone of all your marks during *all* of act 2 needs to be very pale.

Determine now any other areas of your subject whose colours are mainly constituted by the same hue as the pencil you are now holding. You will see in the diagram other parts which are also coloured with the same green-yellow hue of green as in the still-life subject. The larger part in the centre of the composition represents yellow-green grapes and one yellow-brown shadow. Use your chosen coloured pencil as necessary, always constructively, gently and carefully. When you have finished, rest for a few seconds and then enact the next scene.

ACT 2, SCENE 2

Choose another part of your composition that you wish to colour next, and repeat act 2, scene 1 in that part and any other parts which need to be coloured with it. The diagram shows how the orange-red has been used. It starts to represent a red tomato, a red-orange hue of brown for the onion and some red-brown shadows. Remember it is always helpful to rest for a few seconds before you proceed further.

1·1 3·1
1·2 3·2
1·3 3·3
 3·4
2·1 3·5
2·2
2·3
2·4

ACT 3, SCENE 5
(orange-red)

1·1 3·1
1·2 3·2
1·3 3·3
 3·4
2·1 3·5
2·2 3·6
2·3
2·4

ACT 3, SCENE 6
(orange-yellow)

1·1 3·1
1·2 3·2
1·3 3·3
 3·4
2·1 3·5
2·2 3·6
2·3 3·7
2·4

ACT 3, SCENE 7
(purple-red)

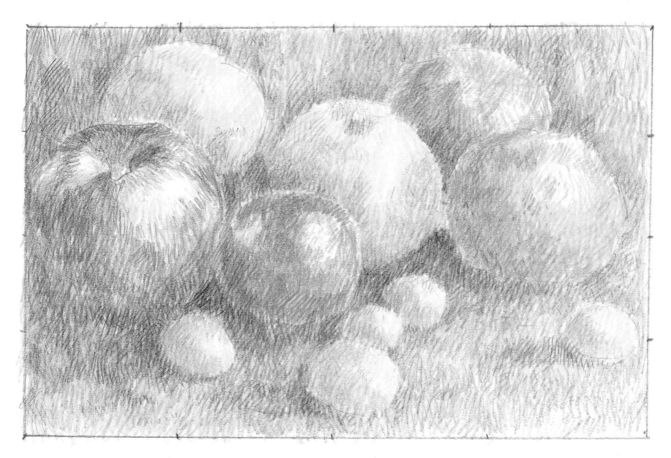

ACT 3, SCENE 8

(purple-blue)

This the final stage – it is reached only by devotion to enjoying the completion of each previous stage.

Remember – enjoy the drawing's 'childhood' as it grows!

CHAPTER TEN

More colour drawing

Your bold adventures in Chapter Nine acted also as an introduction to the escapades you are about to encounter in this chapter. As you were following the drawing procedure in Chapter Nine, you may have realised that you could apply the same procedure to other subjects. I am delighted to tell you that you are absolutely correct, and that you can apply it to all subjects.

The same variety of subjects that you explored in monochrome is about to be presented to you again for investigation with colour. Not only does this provide a continuity to our voyage of discovery, it also ensures a smooth and harmonious passage throughout the rest of our exciting journey together.

Allow me to explain a little more thoroughly the reasons for presenting the same variety of subjects. The combined concepts of repetition of similarities and contrast (*or variety*) of differences are important considerations in both teaching and learning. When we educate ourselves in any new area of knowledge and through any new particular discipline, we need to develop both the fluency and the flexibility of our skills and our understanding. If these combined concepts were separated and each developed without the help and support of the other, the effect could be harmful. However, let us not dwell on the negative, but proceed quickly to the positive.

The practice of drawing several different and contrasting subjects, and returning to draw them again frequently, helps our understanding to develop in depth; at the same time it broadens our knowledge. The way we can transfer aspects of learning from one situation to another is something which you have already experienced and from which you have also benefited. In order to augment this experience, it is worthwhile to look at the example of the Impressionist painter Claude Monet. The illustration opposite shows a detail of one of Monet's many water-lily paintings, which I have reinterpreted with coloured pencils. Monet painted this subject repeatedly for about thirty years because every time he approached it he saw something new. However, it is important to understand that before he created his famous water garden at Giverny, he had painted many and various subjects. Furthermore, he painted them frequently; indeed, sometimes concurrently and as a series. For Monet, the water-lily garden encapsulated his idea of infinity: it was a microcosm of the 'instability of the universe transforming itself under our very eyes'.

The combined concepts of repetition of similarities and contrast of differences can be applied in another but equally useful way to all the escapades we will take together throughout the whole of this chapter.

Art is harmony.
Harmony is the analogy of contraries and the analogy of similarities of tone, of colour and of line.

GEORGES SEURAT

Seurat's statement can be a powerful source of inspiration for all of us. He encourages us to develop our powers of observation even more. Not only may we observe an harmonious balance of contrasting and similar tones, colours and lines in all works of art, we may also observe the same kind of harmony in the natural world because 'art' – being, as he implies, an 'analogy' – reflects this harmony. Moreover, if our drawings in some way resemble or represent our responses to the world, they too are analogies in this sense – they too may reflect this harmony. It is all within our power.

A copy of a detail of *The Water Lily Pond*
by Claude Monet (original: National Gallery, London)

A COPY OF A DETAIL OF *BATHERS AT ASNIÈRES*
by Georges Seurat (original: National Gallery, London)

Throughout this chapter let us observe such harmonies in the subjects we choose to draw, and consider how we may reflect, analogously, such harmonies in our drawings. Let us begin by analysing how Seurat employs these precepts about harmony in his own work, and also how Monet, who reputedly denied theorising, has, in his own way, intuitively employed the same precepts.

At left is a copy I made, using our six coloured pencils, of a detail of Seurat's *Bathers at Asnières*, which hangs in the National Gallery in London. You can see even in this small detail how he employs his own theories.

There are a number of examples of similarities of tones in contraries of colours. The pale orange-red representing the boy's skin in sunlight is the same tone as the streaks of pale blue and green-yellow representing a 'halo' to the left of the orange cap and the boy's back. There is an example of simultaneous contrast depicted in Seurat's use of fine dots of blue on the orange in the area representing the mid-toned shadow on the orange cap. Conversely, in the areas representing the darkest shadow on the cap, orange dots can be seen on dark blue. Furthermore, to the left of the cap on the area representing the water, pale orange-yellow dots can be seen on the mid-toned blue and orange horizontal streaks which depict the water. This repetition of similar dots contrasting with repeated horizontal streaks serves as an example of the use of similarities and contraries of line, because we may suppose that directions of marks, whether they be inner or outer contours, are essentially all 'lines'. *Bathers at Asnières* is one of Seurat's comparatively early works, painted in tiny streaks of paint which he applied in both repeated and contrasting directions. Finally, there is the stunning example of how the orange colour used to represent much of the cap, 'glows' because it is contrasted by the blue colour used to represent much of the water. Violence of contrast is prevented because of the transference and counterchange of these complementary colours which we have just discussed. Thus we look at an extremely varied but nonetheless subtle use of what is, essentially, a simple rule.

Now look again at the detail of Monet's *The Water Lily Pond* (page 97). This also contains several examples of similarities of tones in contraries of colours, as well as similarities of colours in contraries of tone. For example, there is a very small amount of pale red used to represent the lilies, compared with the proportionately large amount of green used to represent trees, reeds, parts of the bridge, water and pads. Dark red, in even smaller amounts, is used to contribute to the lilies. However, it has also been used in very small amounts in all the green areas which have just been described. Similarities and contraries of *line*, which we may understand as direction, can be detected in the repeated horizontal strokes representing the pads. These contrast with the repeated vertical strokes representing willows, water and reflections of willows in the water. This 'line' may also be seen in the resolved balance of obliquely angled strokes which are also used to represent all elements of the composition. Once again we see an immensely complex, but at the same time subtle, use of a simple guiding rule.

My only virtue resides in my submission to instinct. Because I have rediscovered the powers of intuition and allowed them to predominate, I have been able to identify myself with the created world and absorb myself in it.

CLAUDE MONET

Let us now put into practice some of these 'left hemispherical' precepts so that our 'right hemispherical' intuition may allow us to perform with an even greater understanding. Remember to prepare yourself by practising the Golden Cord so that you are ready to perform in a relaxed state of attention and are content and happy in this state. Remember also that all the following suggestions for subjects which you may like to try are illustrated in examples which have followed the same drawing procedure which we practised and performed in the previous chapter.

HANDKERCHIEFS

Lay out the subject in the same way as you did before (page 53), clip some white cartridge or watercolour paper to your drawing board, and either sharpen just one hue of each of the three primary coloured pencils or, if you wish, sharpen all six pencils.

The Crumpled Handkerchiefs (below) is my drawing of this subject. I chose the purple-blue (ultramarine), the purple-red (crimson) and the orange-yellow (gamboge) coloured pencils only. The drawing activity took place on some evenings in January and was lit by a yellow hue of artificial light. The areas of the white handkerchiefs in light, therefore, appeared as an extremely pale tone of yellow. Furthermore, the 'grey' shadow appeared as having a purple hue. Except in the very pale areas which I coloured yellow very lightly, I included all three colours in the progressively pale to dark tones which manifested the shadowed areas, but I used more red than yellow, and more blue than red, because the shadows seemed a blue hue of purple-grey.

Thus the optical illusion of simultaneous contrast between yellow and purple provides the same colour contrast in my drawing. In order to prevent this contrast from being too strong and upsetting the balance of the composition, yellow is present throughout. Contrast of tone is quite apparent and is used to depict the shapes of the picture and in the illusion of folds and creases of the handkerchiefs. The intermediate tones create a gradual progression; only in certain areas is there a sharp contrast from light to dark. Each value is repeated more than once but in different-sized areas throughout the composition. Contrast of line is realised by using both curved and straight contours. Equally, repeated and obliquely angled pencil strokes which tend to incline mostly towards the right are balanced by others which incline to the left.

You will probably have noticed, by this kind of analysis in our own drawings and in the works of others (as we have attempted in those by Seurat and Monet) that the particular concepts of repetition of similarities and contrasts of differences perform particular functions. The repetition of similar elements helps to hold and bind the composition; it is almost the 'pulse' of its existence. The contrast of different elements helps to give the composition its shape and form. The manifestation

THE CRUMPLED HANDKERCHIEFS
Drawn with three coloured pencils

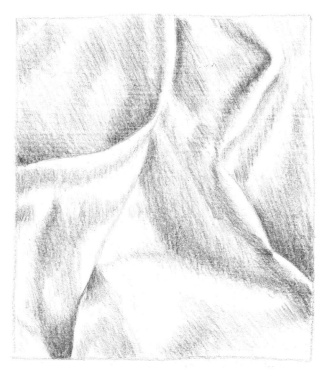

Above: Both these drawings are by Juliet Pollard, a sometime attender of my *Drawing for the Terrified* courses. The pair of drawings depicts two different views of the same crumpled handkerchief. One drawing (left) remains at an almost embryonic stage, whereas the other is quite developed and resembles the subject most realistically. It is a very useful practice sometimes to keep one of such a pair of concurrent drawings at an early stage because, as here, it is then possible to keep a record of how a drawing began and what particular colours were used. It also reminds us of the continuum of our 'voyage' and releases us from the pressure of always having to 'achieve'.

———

of its existence, it imbues it with animation and vitality. Have you noticed how too much repetition can be dangerous? It can lead to predictability, tedium and even banality. Have you also noticed that too much contrast is also dangerous? It could lead to awkwardness, violence and even chaos. A proper balance and a sensitive combination of repetition and contrast together create the total harmony and unity of the drawing, and the completeness and integrity of the composition.

Although space permits the inclusion of only one drawing here, you should, of course, continue to develop two or three drawings concurrently, as discussed before.

CLOUDS AT SUNRISE AND SUNSET

Clouds at Sunset (overleaf) depicts a similar sunset to *Clouds at Sunset* on page 57. The composition likewise derives from a number of thumbnail sketches which have been synthesised to form what can most appropriately be described as 'an artificial depiction based on a number of sequential perceptions'. All six coloured pencils were used. In order to realise the drama of the scene the bias is towards contrast rather than towards similarities. For example, the orange-yellow strip representing the lower part of the sun-filled sky contrasts with the area which represents the upper part of the sky above the clouds, which is a green hue of blue and thus its complementary colour.

This is not a 'snapshot', but represents a combination of phenomena observed over the course of an hour or so. My picture does not lie, exactly; it is a synthesis of one hour's experience brought together for you to behold at a glance.

———

*Art is a lie that makes us realise
the truth.*

PABLO PICASSO

Below is my drawing of a sunrise over the Ribble Valley at Longridge just outside Preston in Lancashire. This drawing is not a synthesis of a number of thumbnail sketches; rather, it was started at seven o'clock one December morning, whereupon I continued to draw until half-past eight, then left and returned to it at about eleven o'clock for half an hour. I had to put into practice a combination of the second, third and fourth drawing procedures which we discussed in Chapter Seven on page 58. You will remember that these procedures entail drawing continuously, as far as we are able, and then either to draw what we recall of earlier tones, colours, lines and shapes, or to change the drawing as these elements change, or indeed to preserve some of the remembered elements with some of the newly formed elements.

When I began drawing, the redness of the sky, being then only slightly paler than the immense darkness of the hills and trees, was paramount. It was this drama that first captured my attention. Then the twinkling lights, in the form of tiny pale yellow spots, shone out from the purple-blue of the distant hills and became a subsidiary plot to

SUNRISE OVER THE RIBBLE VALLEY AT LONGRIDGE

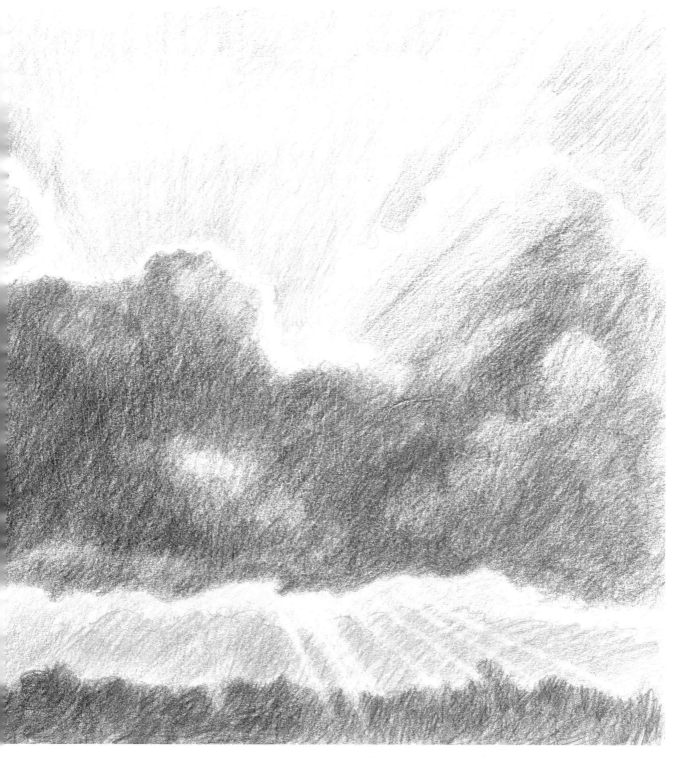

CLOUDS AT SUNSET

BEECH TREES AT SPRINGTIME

Here the orange colour is very much more present than in *Bluebell Wood at Urchfont*, and the blue is in the minority. Curiously enough, because of this, blue's presence becomes that much more noticeable. It would seem to be a law of Nature that where any one element is in a minority, it will always appear as prominent. As far as we are concerned, as artists, this 'law' is very useful to us, because it shows us the way to create a point of interest. However, we must distinguish between prominence and dominance. We have already noted how too much of a contrast of any one element could cause an upset of balance. We have also noted how such an imbalance can be easily and simply resolved by repeating the element in some way. Notice how orange is present less in those areas representing the foliage than in those passages depicting the branches of the trees.

It is also in the area representing the foreground at the base of the picture, depicted as so solid with the glow of autumn leaves as almost to inhibit the presence of bluebells.

The vertical direction given to the depiction of the trees on page 108 yields an alert yet stable aspect to the composition. However, the obliquely angled direction given to the trees on the right illustrated here provides a dynamic quality: notice how the angle of the tree in the foreground leans to the right, and how it is resolved by the angle of the tree immediately to its left leaning in the opposite direction.

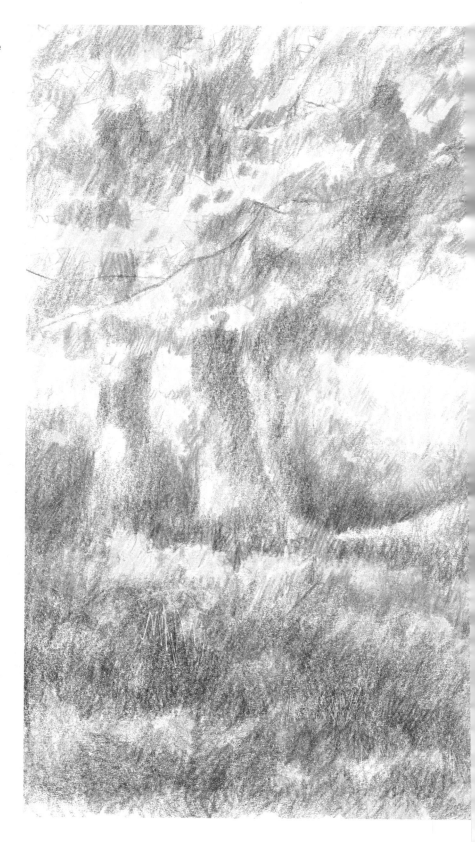

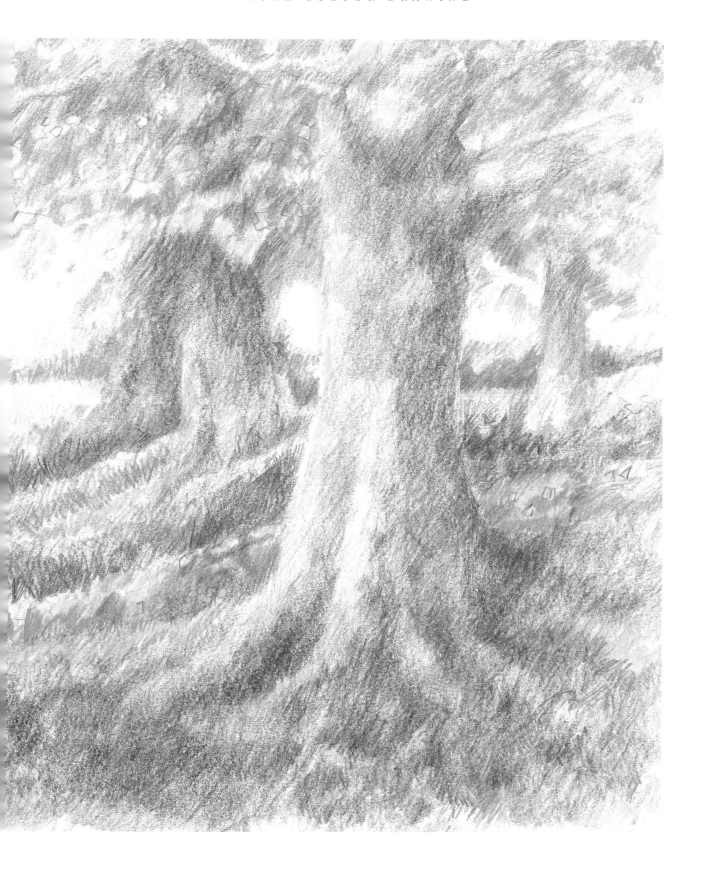

coloured pencils remains just the same as we practised in Chapter Nine. At first glance we might suppose that the initial drawing of the contours of the crab-apple blossom need be done with only the red coloured pencil. However, on closer inspection we can see that yellow and blue make an important contribution to the dark shadowed areas. Remember that all three primaries are, to a certain extent, present in everything in all our drawings.

Also remember that you will benefit from making a number of drawings of the same subject concurrently. The drawings opposite illustrate two such records of my responses to the blossom of a hawthorn bush, which is sometimes called May blossom. The line from Clare's poem encapsulates its abundance when in full bloom and visible all over the countryside.

O'er woods where May her gorgeous drapery flings.

JOHN CLARE

Honeysuckle, Lupins (page 114) and *Poppies and daisies* (page 115) are other examples of flower drawings all on white cartridge or watercolour paper. They represent mainly blooms of summer. *The Yellow Iris* and *The Christmas Rose* (page 116) are chromolithograph illustrations which come from my collection of flower books and date back more than a hundred years. It is thought by some scholars that the Impressionist painters were as much impressed by the system of colour separation used in contemporary printing methods as they were by what they perceived in Nature. They

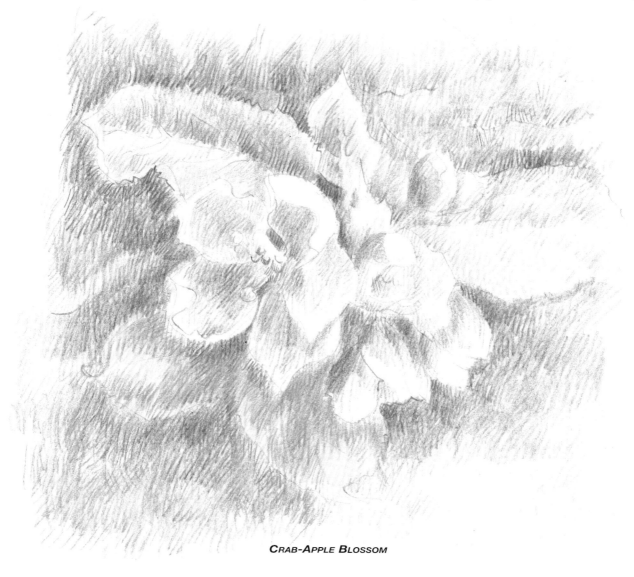

CRAB-APPLE BLOSSOM

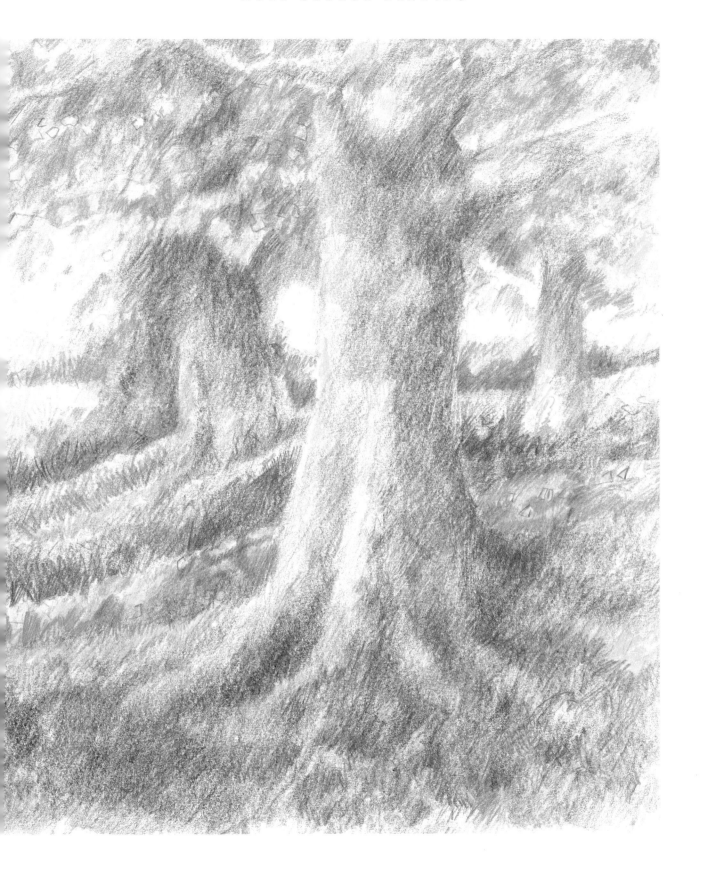

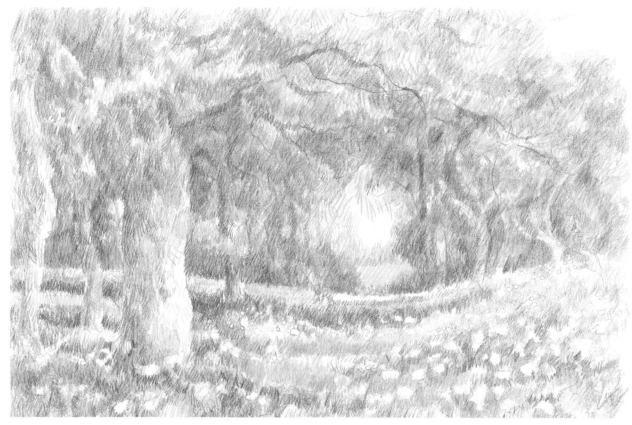

Oak Trees in the Bluebell Wood

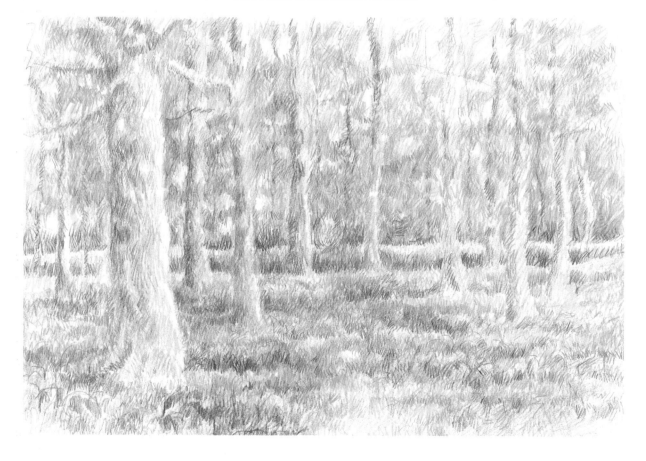

'line', depending on its particular inclination or direction, seems to impart or instil a psychological power in the beholder. Horizontals and verticals appear as stabilisers, horizontals seeming restful, as distinct from verticals which seem alert. All diagonals appear as dynamic. However, they appear more so as they incline towards forty-five degrees rather than towards either the vertical or the horizontal. This is all very much to our purpose, if we wish to impart a particular feeling or psychological atmosphere in our drawings.

Not only is this power imbued in line but also in colour, in its hues, tones and chromatic values. Artists throughout the centuries have known this. Many have written about it; some have even postulated theories. As far as we are concerned, however, all that we need to do is observe their powers and employ them to represent what we both see and feel. Allow such means to represent our total response.

Harmonies are concords of colours which are sufficient in themselves and which succeed in touching us, to the depths of our being, without the aid of a more precise or clearly enunciated idea.

CLAUDE MONET

Opposite below:

BLUEBELL WOOD AT URCHFONT, WILTSHIRE

Here the 'line' in one sense is more severe; yet in another sense it is more serene. The emphasis is on a mainly vertical and horizontal aspect with straight contours and less emphasis on obliquely angled inclinations with curved contours. All kinds are present to a certain extent in order to resolve the balance. We are focusing upon emphasis. 'Tone' is evenly, regularly and similarly distributed. As Seurat says, 'Tranquillity of tone is equality of dark and pale.' Perhaps this drawing also has a 'melancholy' effect. It is certainly 'cool', the warm orange being less dominant than the analogous and cool colours of blue and green. Warm red and orange are present in the areas representing the tree trunks and their branches, but they are in the minority. There is enough of them to create a balanced harmony but not enough to detract from the cool, still, tranquil atmosphere of the scene. This is how it was in the subject; this is my attempt to record it. Once again, Nature provides, I try to obey. As Francis Bacon said, 'Nature is not governed except by obeying her.' This drawing was developed from sketches, other drawings and photographs.

Colours, though less diverse than lines, are nevertheless more explanatory by virtue of their power over the eye. There are tonalities which are vulgar, harmonies which are calm and consoling, and others which are exciting because of their boldness.

PAUL GAUGUIN

Cheerfulness of tone is the bright dominant; of colour, the warm dominant; of line, lines above the horizontal. Tranquillity of tone is equality of dark and pale; of colour, of warm and cold; and the horizontal for lines. Melancholy of tone is the cold dominant, and of line the downward direction.

GEORGES SEURAT

FLOWERS

Let us start this section with one of the subjects in the equivalent section of Chapter Seven (page 64). Crab-apple blossom's delicate hue of pale red contrasts serenely with the young yellow-green leaves. Nature's system of balancing complementaries and creating concordances with colour's hues, tones and chromatic values is never arbitrary. It is always unapproximate, and perfectly harmonious. *Crab-Apple Blossom* (page 110) illustrates my attempt to portray this wonderful example of Nature's harmony.

Once again, as with all our coloured drawing in this chapter, only the primary colours are used. However, I believe that the time has come to suggest that you could increase the number of hues if you need to do so. I find that, whereas the two blues and the two yellows serve my responses very sufficiently, the range of reds is occasionally inadequate, especially if I need to make a particular hue such as a clear purple. In this example of the crab-apple blossom the colour in the buds and some of the young petals is of a red which we could almost designate as purple. The extra coloured pencil I now include is sometimes called 'magenta' or even 'shocking pink'.

Remember that our procedure of drawing with

coloured pencils remains just the same as we practised in Chapter Nine. At first glance we might suppose that the initial drawing of the contours of the crab-apple blossom need be done with only the red coloured pencil. However, on closer inspection we can see that yellow and blue make an important contribution to the dark shadowed areas. Remember that all three primaries are, to a certain extent, present in everything in all our drawings.

Also remember that you will benefit from making a number of drawings of the same subject concurrently. The drawings opposite illustrate two such records of my responses to the blossom of a hawthorn bush, which is sometimes called May blossom. The line from Clare's poem encapsulates its abundance when in full bloom and visible all over the countryside.

O'er woods where May her gorgeous drapery flings.

JOHN CLARE

Honeysuckle, Lupins (page 114) and *Poppies and daisies* (page 115) are other examples of flower drawings all on white cartridge or watercolour paper. They represent mainly blooms of summer. *The Yellow Iris* and *The Christmas Rose* (page 116) are chromolithograph illustrations which come from my collection of flower books and date back more than a hundred years. It is thought by some scholars that the Impressionist painters were as much impressed by the system of colour separation used in contemporary printing methods as they were by what they perceived in Nature. They

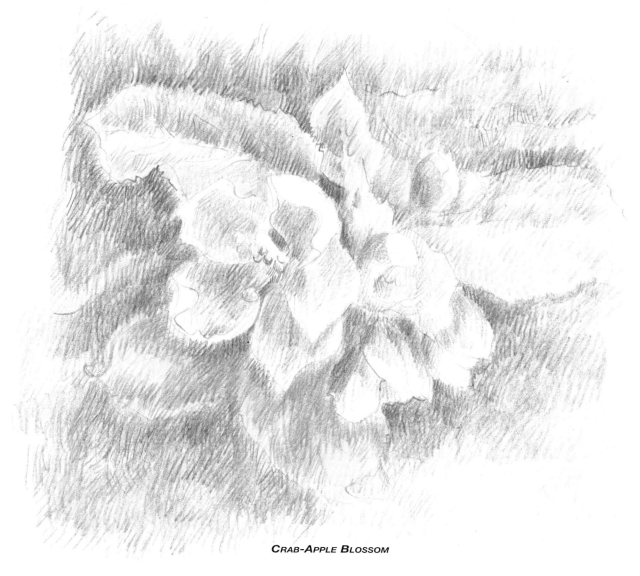

CRAB-APPLE BLOSSOM

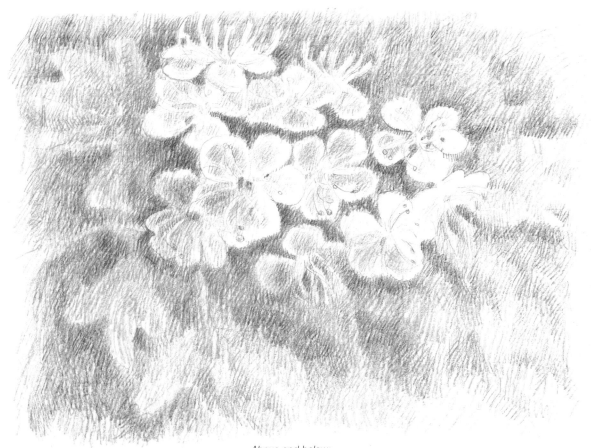

Above and below:

MAY BLOSSOM

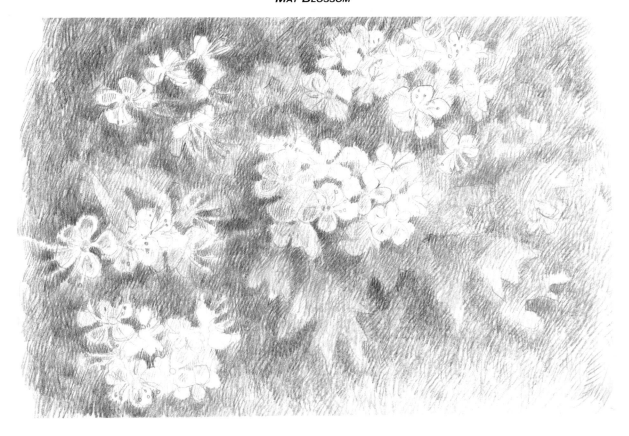

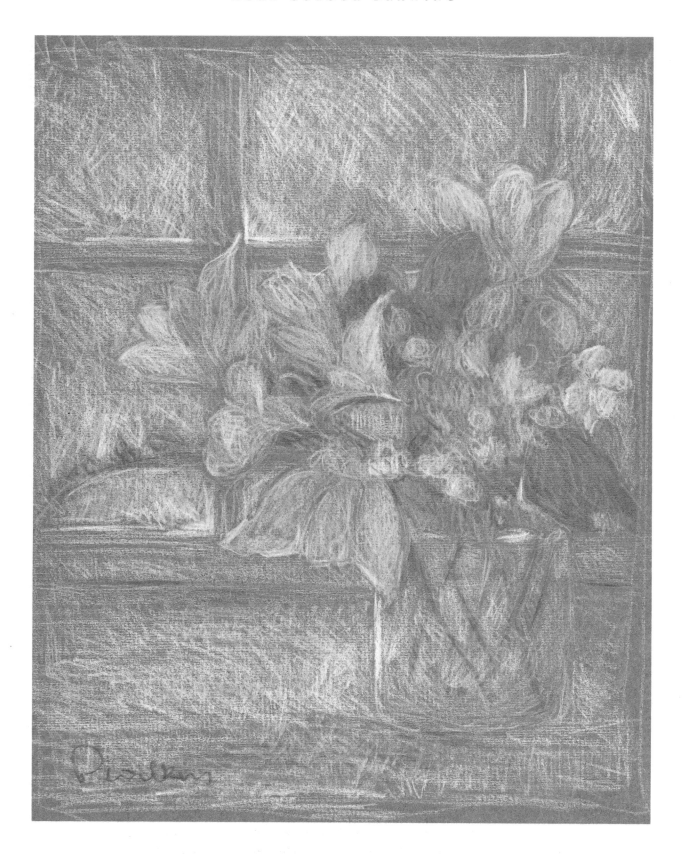

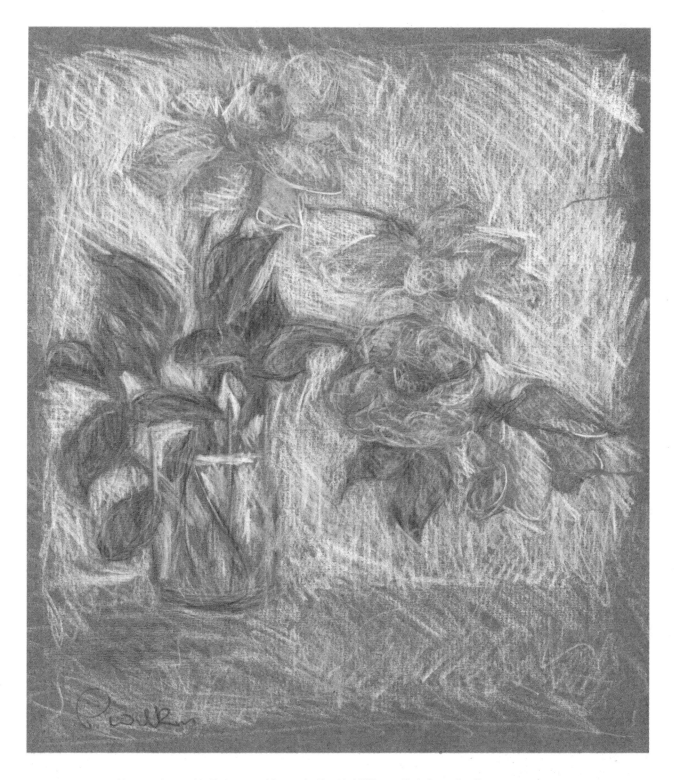

Above and opposite: Two vases of flowers by Pamela Wilkinson. Both these drawings were made on tinted paper, known as 'Ingres paper', which you might like to try. Because the tonal value of the paper is darker than we normally use, you will find that if you exercise strong pressure on the paler-toned pencils you can create a tone paler than the paper. What is transparency on white paper becomes opacity here. You will see in both illustrations that even a white coloured pencil has been included. Essentially the drawing procedure is the same. The only difference is that Pamela began with the mid-tone of the paper and gradually drew towards the palest and darkest tones systematically.

HONEYSUCKLE

are certainly excellent examples of how we might consolidate our understanding of colour. Look at *The Yellow Iris* (page 116) and you will see how blue and red dots of ink darken the yellow to represent the shadows on the iris. Look also at the leaves of the iris and you will detect that red dots are not only present at their tips but also help to darken their shadows. *The Christmas Rose* (page 116) is a splendid example of how all three primaries of a pale tone create the grey shadow on the petals. The shadow in the yellow centre is created by dark tones of all three primary colours which produce the appearance of brown. Brown is present in other parts of the picture, and we can see how red is used more than yellow and blue to make it this colour.

LUPINS

POPPIES AND DAISIES

THE CHRISTMAS ROSE

Nineteenth-century chromolithograph by Ethel Nisbet, an illustration in her book, *Flower Painting for Beginners* published by Blackie and Son Ltd.

THE YELLOW IRIS

Nineteenth-century chromolithograph 'figured' by F. Edward Hulme from *Familiar Wild Flowers* published by Cassell, Petter and Galpin.

ALL CREATURES, GREAT, SMALL AND HUMAN

We have arrived at the point in our voyage of discovery together when we return again to our animate friends, including us human beings!

A beagle puppy, *A mallard duck* and *A heifer* (overleaf) are samples from a selection of quick studies, thumbnail sketches and small drawings from pages in my sketchbook and on odd scraps of paper. You have all now learned that sketching in colour helps to describe the form as effectively as in monochrome. In some ways it is more useful because it saves having to write notes in your sketchbook about a particular colour, which is not nearly so helpful as actually using colour itself. Most useful of all is to sketch in both monochrome and colour. Keep your sketchbook alive and quicken your resolve to use it every day.

For the remainder of this chapter we will focus on just a few subjects, which will be treated in quite different situations.

The stuffed fox (below) illustrates my drawing of another view of the stuffed fox we saw on page 14. My local museum operates a loan service, but I decided that my cats would object to a fox, even a stuffed one, being brought into their territory, so I decided to draw it in the museum. I have followed our drawing procedure as precisely as possible, using all six coloured pencils. I noticed that, although the shape of the fox and his proportions are immensely subtle and complex, his colour, an orange-brown, is basically quite simple. Essentially, he is an orange-coloured ball!

You will, I hope, recognise my black-and-white cat again as depicted in *My Cat* (page 120). She is certainly interested in watching me write this manuscript! Again, I used all six coloured pencils and followed the same drawing procedure. She, essentially, is a black colour ball. (Actually, her fur is a red-black and in certain lights it positively glows.)

This cat, you will remember, visits me only briefly every day. This and the monochrome

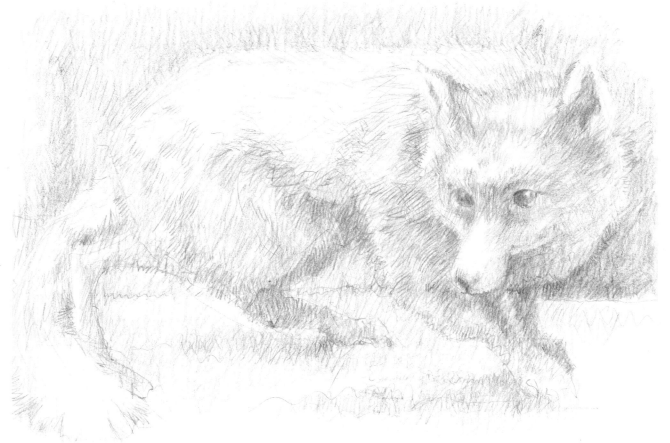

THE STUFFED FOX

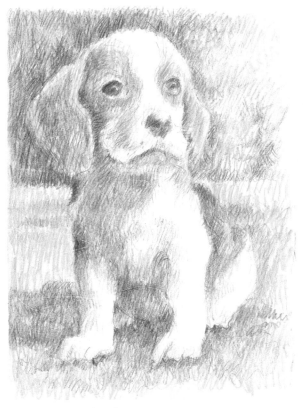

A *BEAGLE PUPPY*

drawing on page 69 were developed concurrently but over a time-span of two or three weeks. Both drawings of the fox were also developed concurrently but over a time-span of two or three hours.

Finally, let us conclude with the human figure. The top drawing on page 121 illustrates one of my attempts at portraiture. As before, you can begin with statuary and portraiture before moving on to real-life situations. (I hope by now you have also joined a life class.) Do please remember that, in order to achieve reasonable proportions which resemble the subject at which we are looking, we need *regular* practice. Try not to be swayed into negation by what might appear as 'difficult': just say to any negative thought, 'Not today thank you! I am on an adventure.'

There are moments in our lives, there are moments in a day, when we seem to see beyond the usual. Such are the moments of our greatest happiness. Such are the moments of our greatest wisdom.

ROBERT HENRI

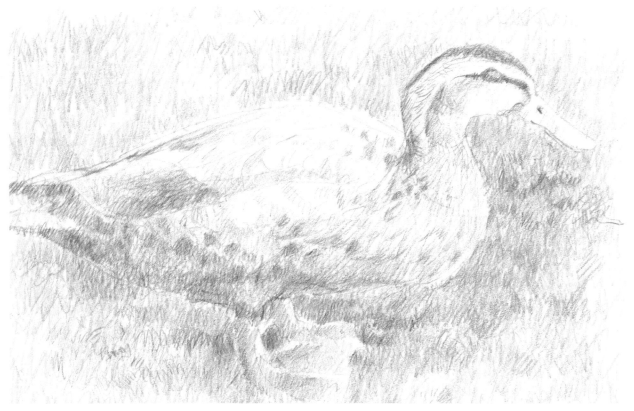

A *MALLARD DUCK*

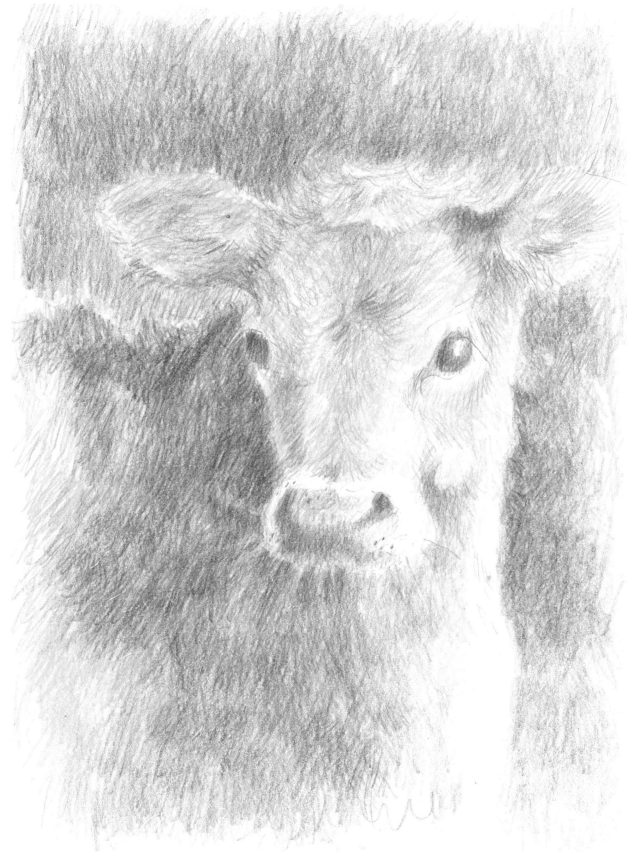

A *HEIFER*

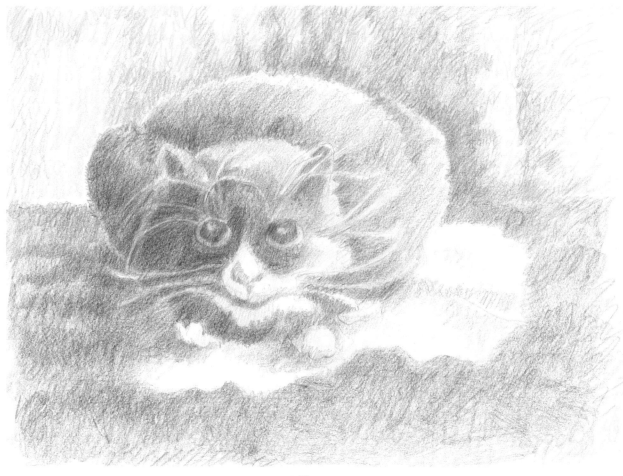

MY CAT

KEEPING TERROR AT BAY

As your instructor, it remains only for me to set your homework.

You know what to do. However, there are three precautions we must take to apprehend any invading 'giants'. One is to find ten minutes a day to devote to drawing. You know that if you really want to do something you will find the time to do it. The second is to find the place and have your equipment ready and waiting for you. I know, and so do *you*, that we can only too readily put off our endeavours and prevent ourselves from playing because of the bother and effort of getting everything ready!

The third precaution we need is the most important. We need the justification to do what is still considered by many as a flippant pastime. We have discussed throughout the whole of this book what the purpose of drawing really is. We have read about its essential reason which many sages have long since known about, and I wish to conclude this book with some more wise words. As we began, so shall we end – with a story.

A PORTRAIT OF STEPHEN MEAD

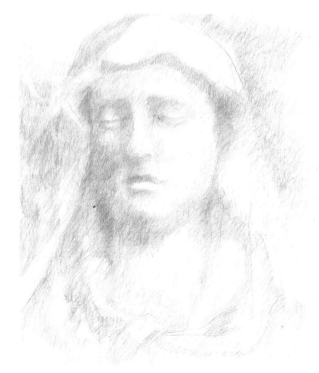

A STUDY OF A MARBLE BUST

Conclusion

You may, one day, read the original. My version, after much telling, is slightly altered. Nevertheless, the essential meaning is there: however nasty, horrific and ghastly are the things that beset us throughout life, there is also, however small, something always present for our enjoyment.

THE STRAWBERRY – A PARABLE

You will remember our king in the giant story on page 6. On his journey to find the hidden treasure he became aware that he was being chased by a tiger. He came to a precipice and immediately caught hold of a wild vine and jumped over the edge. The vine took him but halfway down the precipice. Above, the tiger sniffed angrily. Below, the king beheld another tiger waiting to eat him. Then two mice, one white, the other black, started to chew the roots of the very vine which supported our hero. Fortunately, he noticed that a strawberry was growing nearby and within his reach. All he had to do was stretch out his hand and pluck the strawberry, and he only had to take one bite to know that it was the most wonderful thing he had ever tasted. He had found the treasure! Have you?

THE STRAWBERRY

Glossary

Words and phrases can have different meanings for different people at different times and in different places. My definitions may not meet the approval or agreement of all. However, the following brief descriptions refer to how I have intended these terms to be understood in the context of this book.

Analogy A similarity, equivalent, metaphor, parable, simile, eg, analogous colours are similar colours.

Analytical Refers to the ability to abstract particular parts or specific relations from generalities.

Assessment The ability to observe objectively, and to understand what has been done and is being done.

Attention The ability to be fully observant without being distracted by irrelevances.

Balance Matching, bringing into equilibrium, regulating extreme differences, equalisation.

Chromatic value The quality that refers to any value within the range between bright and dull.

Colours The constituent parts of decomposed rays of light and the general name given to those elements: red, orange, yellow, green, blue and violet or purple.

Complementary Refers to an element or quality which usually contrasts with, or is in opposition to, another element or quality.

Composition The harmonious relation of all parts, elements and qualities of a whole.

Concurrent The running or existing together of two or more activities to which attention is given alternately but not simultaneously.

Configuration The shape, aspect or character produced by the relative position of its parts.

Contrast The emphasis of differences between things, elements or qualities by close juxtaposition.

Cross-hatching A method of drawing by means of crossed parallel lines in order to achieve a type of shading or certain coloured effects.

Design The plan or organisation of all parts of an activity or any created object, to compose a coherent order and unity.

Drawing The representation, portrayal and realisation of a person's response to the world.

Elements The components that contribute to the structure and substance of any created object such as edge, line, shape, form, tone, colour and texture.

Evaulation The ability to recognise the value in that which has been done and is being done for present and future use.

Form (noun) A shape that is often comprehended in three dimensions, but also sometimes understood in two dimensions.

Form (verb) To create, construct and make.

Harmony The balanced combination of various qualities and elements, usually comprising those that are both similar and complementary.

Hatching A method of shading with parallel lines.

Holistic Refers to the ability to understand whole things altogether at once.

Hue The quality that distinguishes one particular kind of colour from another such as a blue-green and a yellow-green.

Inspiration The influence infusing the thought, feeling and spirit ('breath') of the maker, thus animating the object created.

Integrity The state of wholeness and completeness, entire in and of itself.

Knowledge That which is discovered and understood (an empirical definition only).

Line A term used in three different ways: (a) that which represents an edge or contour of a shape; (b) a very thin shape; (c) that which denotes direction.

Local colour The intrinsic colour of any particular object such as a *red* apple.

Local colour tone The intrinsic tonal value of any particular object such as a *dark* red apple or a *pale* green grape.

Logical Refers to the ability to reason and to reach conclusions by following an ordered sequence of thought.

Perception The detection and recognition of sensations and stimuli within the environment.

Process The activity of doing and proceeding with awareness.

Rational Refers to the ability to make decisions based upon information, facts and reasons.

Realisation That which has been made manifest and real such as a drawing.

Recipe A particular way or procedure of engaging in an activity by means of certain rules.

Rules Guidelines to assist the process or procedure of any given activity, exercise or game.

Sensitivity The ability to be exceptionally aware and appreciative of impressions.

Shade (noun) A dark tone.

Shade (verb) To darken, such as with pencil lines in drawing.

Shape An area perceived in two dimensions.

Spatial Refers to the ability to understand how individual parts relate to one another.

Texture The surface quality of any physical substance.

Tint A light or pale tone.

Tone (or *tonal value*) The quality that distinguishes anything within the range between light and dark.

BIBLIOGRAPHY

Arnason, H. H., *A History of Modern Art*, revised edition, Thames and Hudson, 1977

Benham, W. Gurney, *Cassell's Classified Quotations*, Cassell, 1921

Bloomer, Carolyn M., *Principles of Visual Perception*, Van Nostrand Reinhold, 1976

Clucas, Phillip, *Country Seasons*, Windward, 1978

Collingwood, R. G., *The Principles of Art*, Oxford University Press, 1979

Cotteral, Lawrence (ed), *100 Favourite Poems of the Countryside*, Piatkus, 1990

Edwards, Betty, *Drawing on the Right Side of the Brain*, Souvenir Press, 1981

Frank, Frederick, *The Awakened Eye*, Wildhouse (UK), Bookwise (Australia), 1980

Fry, R., *'Seurat'* in *Encyclopaedia Britannica*, 1971

Gibran, Kahil, *The Prophet*, Heinemann, 1979

Hamilton, George Heard, *Painting and Sculpture in Europe 1880–1940*, revised edition, Penguin, 1978

Henri, Robert, *The Art Spirit*, Harper and Row, 1984

Itten, Johannes, *The Elements of Colour*, Van Nostrand Reinhold, 1970

Jekyll, Gertrude, *Wood and Garden*, The Ayer Company, 1983

Leach, Michael, *The Secret Life of Snowdonia*, Chatto and Windus, 1991

Lowenfeld, Victor, *Creative and Mental Growth*, fifth edition, Macmillan, 1970

Malins, Frederick, *Understanding Paintings: The Elements of Composition*, Phaidon, 1980

McKim, Robert H., *Experiences in Visual Thinking*, second edition, Wadsworth, 1980

Murray, Peter and Murray, Linda, *A Dictionary of Arts and Artists*, third edition, Penguin, 1975

Mussen, Paul H., Conger, John J. and Kagan, Jerome, *Child Development and Personality*, fifth edition, Harper and Row, 1979

Richter, Irma A., *The Notebooks of Leonardo da Vinci*, Oxford University Press, 1980

Ruskin, John, *The Elements of Drawing*, Dover, 1971

Shree Purohit Swami, *The Ten Principal Upanishads*, Faber and Faber, 1970

Swami Vivekananda, *Work and its Secret*, J. N. Dey at Union Press, 1976

Taylor, Pamela, *The Notebooks of Leonardo da Vinci*, Plume New American Library, 1960

Wood, James, *The Nuttall Dictionary of Quotations*, Frederick Warne, 1930

ACKNOWLEDGEMENTS

I am pleased to have this fortunate opportunity to thank the many people who played a part in the production of this book: to all the staff at the Adult Education Centres where I teach *Drawing for the Terrified* courses, particularly those at Alston Hall, Missenden Abbey and Urchfont Manor for their continued support and encouragement; to the staff at The British Museum, The National Gallery, Hereford Museum and the Victoria & Albert Museum for their invaluable educational ethos and helpful assistance; to Philip Price for my photograph on the back jacket flap; to Sally Blenkinsop, Juliet Pollard, Lois Thwaites and Pamela Wilkinson for allowing their drawings to be illustrated; for the same reason to all the children who attended my Saturday morning art classes in the 1980s (and who forgot to sign their drawings!); to my editors at David & Charles, Alison Elks, Kate Yeates and Freya Dangerfield, for their guidance and kind reassurances; to Pauline Garnham (whose middle fingers are now markedly shorter) for her time, energy and incredible patience in typing the manuscript so cheerfully; and finally, to all of the past, present and future *Drawing for the Terrified* students who have created the gradual evolvement and development of this course and which is now presented between these covers.

Without you, it would not have been possible.

Thank you all!

INDEX

Numbers in **bold** indicate
illustrations